THE EAST NEUK OF FIFE

THROUGH TIME

Jack Gillon

AMBERLEY

First published 2015

Amberley Publishing
The Hill, Stroud
Gloucestershire, GL5 4EP

www.amberley-books.com

ISBN 978 1 4456 5349 5 (print)
ISBN 978 1 4456 5350 1 (ebook)

British Library Cataloguing in Publication Data.
A catalogue record for this book is available from
the British Library.

Typesetting by Amberley Publishing.
Printed in the UK.

Introduction

Few districts in the country present a greater number of attractions to summer-visitors than that which stretches along the shore of the Forth, from Fifeness to Leven, and which is known as the East Neuk of Fife. The bracing sea-breezes, the clear, blue waves, the flat, sandy beaches, the wild and precipitous cliffs, the remarkable caves, the golfing-links, the fine old churches, the quaint old towns, the ruined castles, the delightful dens, the curious antiquities, the historical associations, the romantic traditions, the beautiful landscape, the magnificent views, the pleasant drives and walks and rides may all be enjoyed leisurely in this quiet, easy-going corner.

Guide to the East Neuk of Fife, D. Hay Fleming, 1886

Neuk is the Scots' word for nook or corner, and the delightful East Neuk in the Kingdom of Fife, with its cluster of picturesque fishing ports and farming communities, is one of the most attractive little neuks in the country.

There is some debate about what geographical area constitutes the East Neuk. For the purposes of this book, it has been taken as the eastern peninsular part of Fife, between a line from Kingsbarns in the north to Lundin Links to the south. This is also reflected in the positioning of signboards welcoming visitors to the East Neuk, which are located on the north side of Kingsbarns and to the south of Lundin Links.

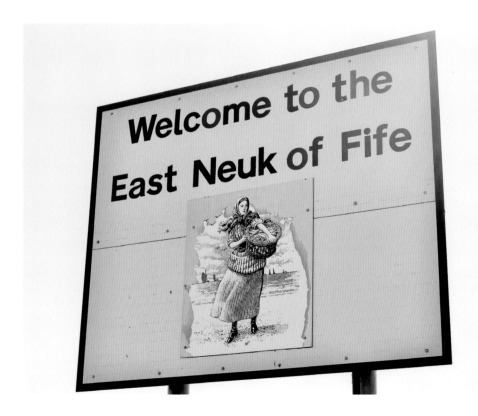

The East Neuk villages have a character which is quite distinct from other parts of Scotland. They have survived relatively unchanged for centuries with their narrow streets and local vernacular architecture, due to their geographical isolation. The remote nature of the East Neuk is reflected in the old Fife story which relates how a man, when asked if he had ever travelled abroad, replied: 'Na, but I ance kent a man who had been to Crail.' This relative remoteness, but proximity to the Central Belt of Scotland, made it the perfect choice for the Cold War secret bunker, which would have been the main seat of government in Scotland in the event of a nuclear conflict.

The coastal villages, with their natural harbours, are witness to the long tradition of fishing in the area, which was 'vigorously prosecuted here for centuries' with harbours overflowing with boats. King James VI called the area 'a beggar's mantle fringed with gold' – the mantle being the rugged coastline and the gold the thriving fishing villages of the time. The area also has some of the best farmland in Scotland and the East Neuk farmers historically 'long led the van in agricultural progress'.

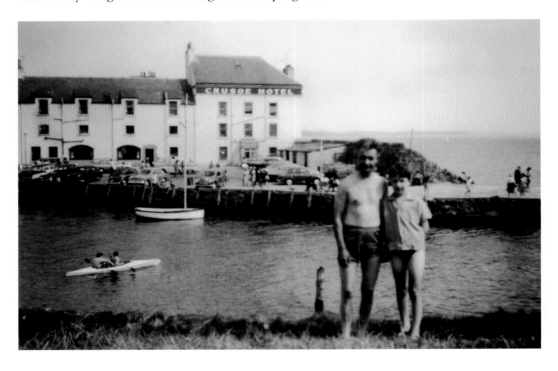

The area draws visitors from near and far to experience its many charms. My own affection for the area is based on the happy days of annual childhood holidays spent in Lower Largo. It was a time when life seemed to be lived at a slower pace – when it was the best possible fun to fish aimlessly from the harbour, bury my dad in the sand, mess around in rock pools and feast on fish and chips wrapped in newspaper.

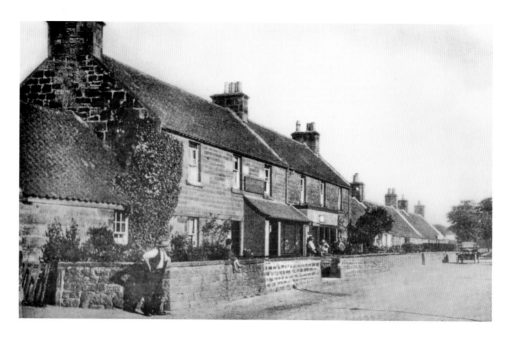

Kingsbarns, Main Street

Kingsbarns takes its name from the local granaries, which once served Falkland Palace. A pier was built on the coast at Kingsbarns for ships used to transport local agricultural produce to markets and it was later improved as a base for the construction of the Isle of May lighthouse. Kingsbarns also had its own railway station to the west of the village, which opened in 1883 and operated until 1930 for passengers and 1965 for freight. In the mid-nineteenth century the village was a centre for linen weaving and there were a number of stone quarries in the locality. The post office has been located in the building in the middle of this row of cottages since the mid-nineteenth century.

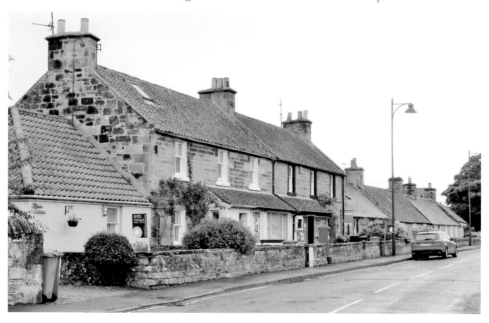

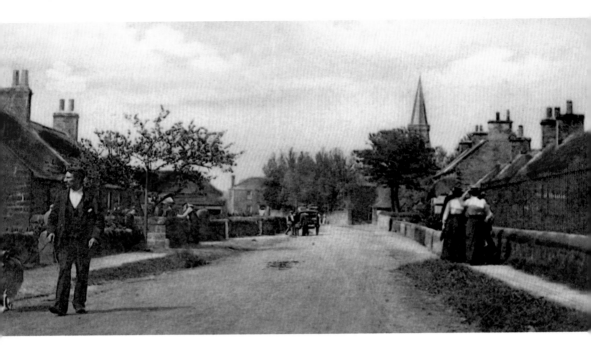

Kingsbarns, Main Street
It seems like a leisurely day in the older image of Kingsbarns – elegantly dressed ladies, possibly heading for a church service, a horse and cart making a delivery; some people catching up with gossip over a garden wall; and a man taking his sheep for a walk on a lead.

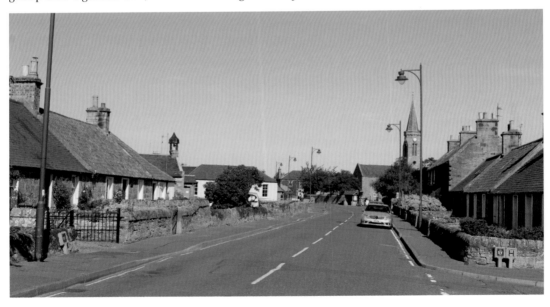

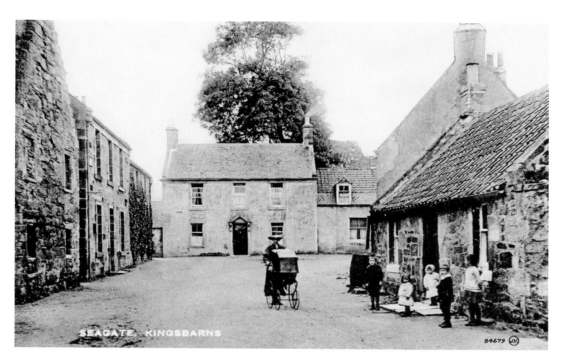

Kingsbarns, Seagate
A view looking west on Seagate towards the classically proportioned late eighteenth-century Grey House.

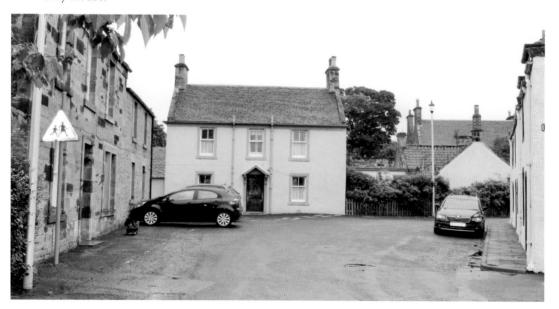

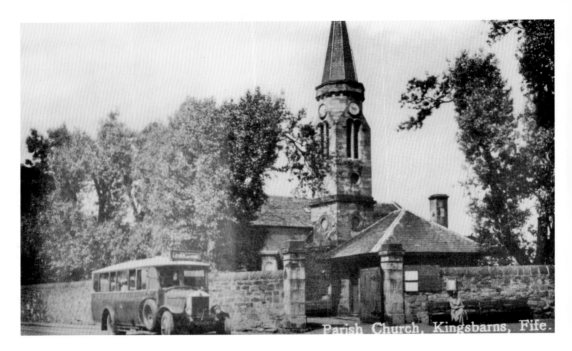

Parish Church, Kingsbarns, Fife.

Kingsbarns Parish Church

The original church at Kingsbarns dates from 1631 and the lower parts of the tower date from the late seventeenth century. It was largely rebuilt in the mid-eighteenth century and considerably altered in the early nineteenth century. The top stage of the tower and the octagonal slated spire date from 1865–6. The tower is an important focal point in the village. The motorbus in the older image is bound for Leven.

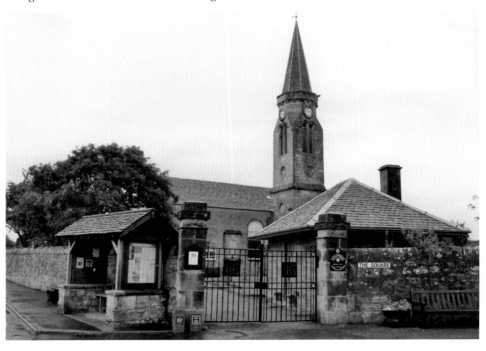

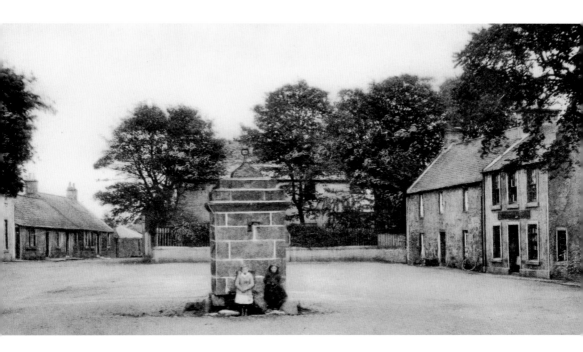

Kingsbarns, The Square
The older image shows a bucolic view of the village square with two young girls standing beside the historic water pump. The area now serves as a car park.

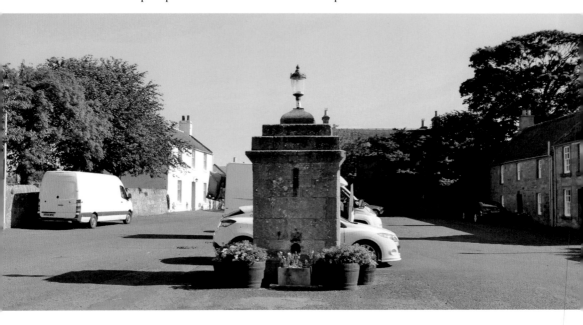

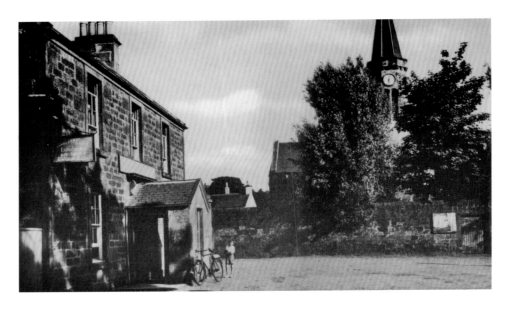

Kingsbarns, Former Cambo Arms Hotel

There has been a coaching inn on this site as far back as the seventeenth century. The present building dates from the early nineteenth century. The Cambo Arms closed in 2000 and there were proposals to convert the building into two houses. This was vigorously opposed by local residents and permission for the conversion was refused on the basis that the loss of the pub would be detrimental to the character of the village. The premises reopened as a pub and is now known as the Barns.

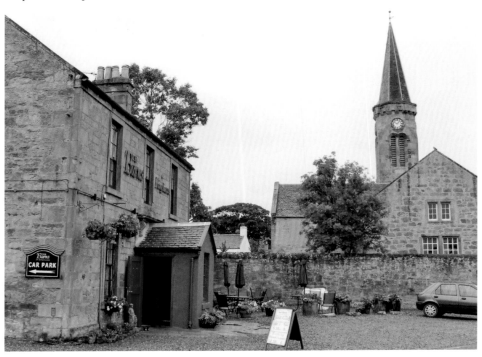

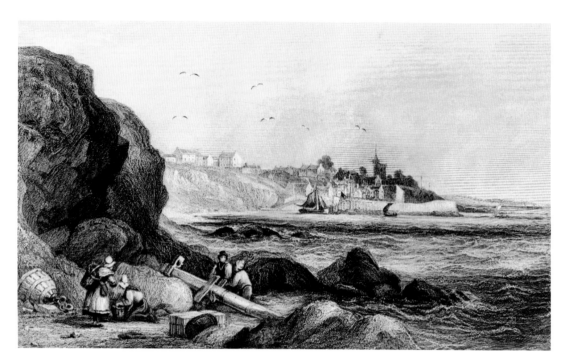

Crail

Crail takes its name from the Pictish word *caer* meaning 'fort' and the Gaelic word *ail* meaning 'rock' – this relates to the medieval castle which once stood overlooking the harbour on the site of Crail House and which fell into ruin by the sixteenth century. The town appears in various ways in old records, including 'Karaill' and 'Karal'. Crail was created a royal burgh by David I in the twelfth century, although the earliest extant burgh charter dates from 1310. From the twelfth century onwards Crail developed as a mercantile town, trading with the Flemish and Dutch.

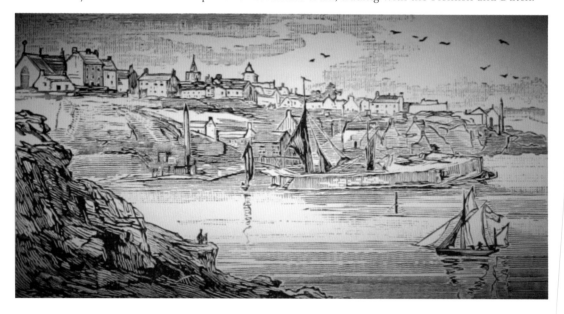

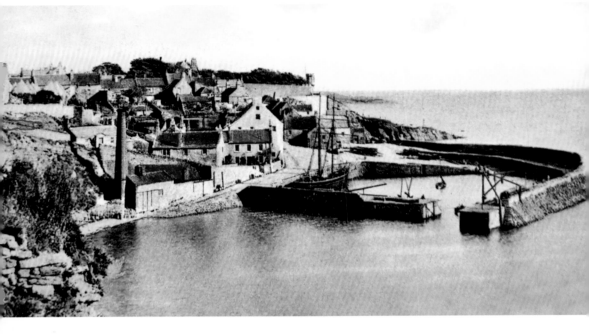

Crail Harbour

The view of the picturesque harbour at Crail from West Braes. It was originally designed for small trading or fishing vessels, and so had a narrow harbour entrance. The curved breakwater dates from the early seventeenth century and the straight west pier was added in 1826–28, to the design of Robert Stevenson. The harbour is surrounded by buildings with white harled walls and red pantiled roofs that date back to the seventeenth century. Fishing was the main industry in Crail in the early eighteenth century. However, it was in steep decline by the end of the century and the harbour was too small to accommodate the larger fishing boats that came into use in the nineteenth century.

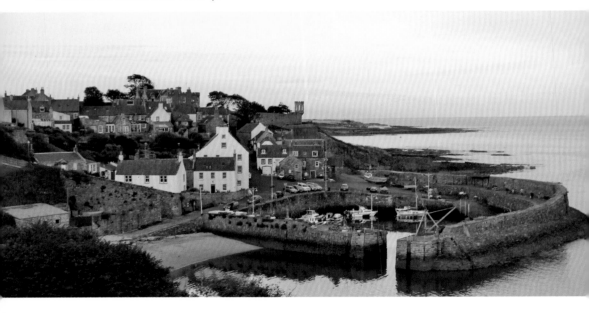

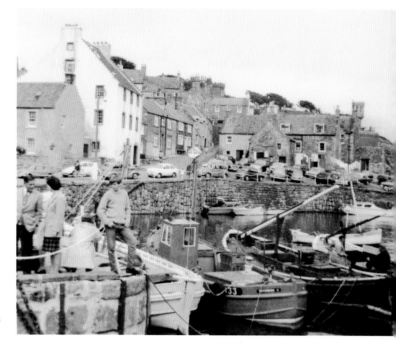

Crail Harbour

The harbour at Crail is without doubt the most scenic in the East Neuk – it has even been recreated in miniature at Legoland in Denmark. The older image shows a busy scene at Crail harbour in the early 1960s. The large seventeenth-century custom house building on the left has a plaque bearing the town arms and reflects the previous importance of the fishing industry in Crail. The last herring were landed at Crail in 1943 and a small number of creel boats still go partan (edible crab) and lobster fishing, with locally caught fresh shellfish available for sale at the harbour.

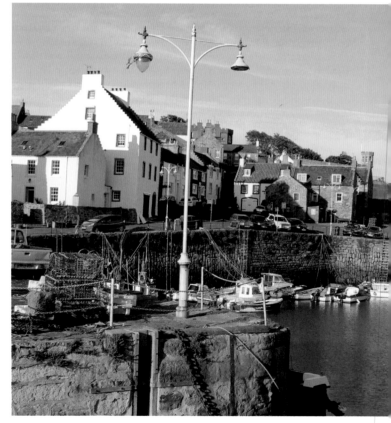

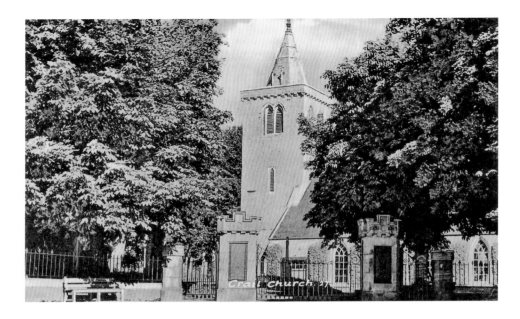

Crail, Parish Church, Marketgate

Crail parish church dates to the twelfth century, which makes it one of the oldest religious sites in continuous use in Scotland. The graveyard contains a battlemented morthouse of 1826, in which bodies were kept for six weeks in summer and for three months in winter before they were buried as a precaution against the resurrectionists. The gates to the church are memorials to the dead of both world wars. A Celtic cross slab, dated to around 800 AD, is preserved against the western wall of the church – the cross allegedly had prodigious healing powers. Legend has it that a large boulder called the Blue Stane near the church gate was thrown by the Devil from the Isle of May – a circular imprint on the stone is said to be the Devil's thumb-mark. John Knox delivered a sermon in the church condemning the fishermen of the East Neuk for working on a Sunday.

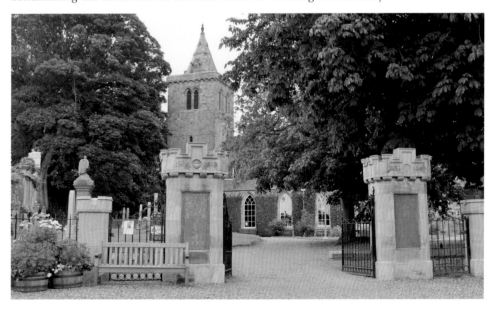

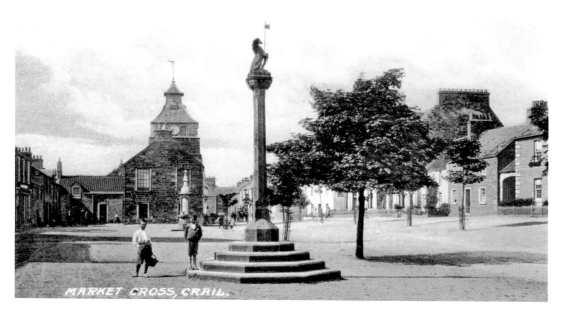

MARKET CROSS, CRAIL.

Crail, Marketgate

Crail developed round the harbour and marketplace and retains much of its early medieval street pattern. Crail's Marketgate was one of the largest marketplaces in medieval Scotland. An Act of Parliament passed in 1584 specified that all the 'fishers, and slayeris of hering and quhyt white fish', dwelling on both sides of the Forth and to the mouth of the Tay, should bring their 'hering and quheit fishe' either to Leith or Crail. By the mid-1880s, it was noted that Crail has 'of late become a favourite resort for summer visitors' and the opening of Crail railway station in 1887 boosted its popularity as a holiday resort.

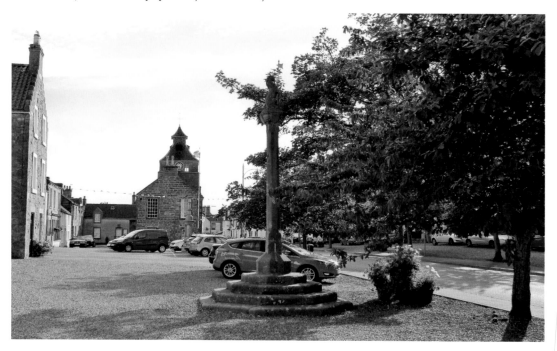

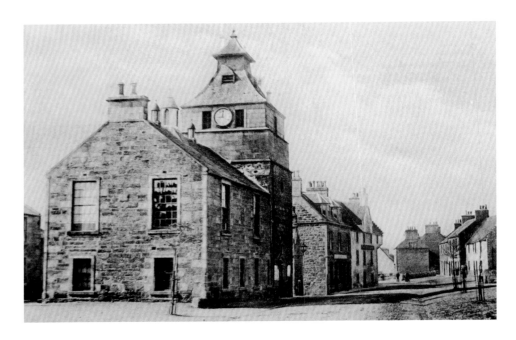

Crail Tolbooth

Crail tolbooth was the governmental centre of the town and housed the jail. Its distinctive roof dates from the late sixteenth century, although the bell tower and clock were a later addition in 1776. The bell, which dates from 1520, was cast in Rotterdam and reflects the town's links with the Dutch. The weathervane in the shape of a fish is a reminder of the Crail capon, a smoked haddock, a delicacy which the town produced in great quantities and that made Crail famous. The adjacent town hall dates from 1814 and replaced an earlier town house of 1602. Nothing remains of the sixteenth-century town wall which surrounded the town.

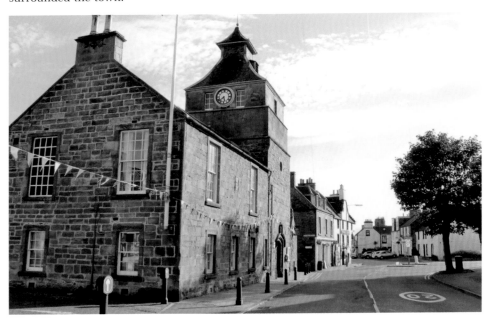

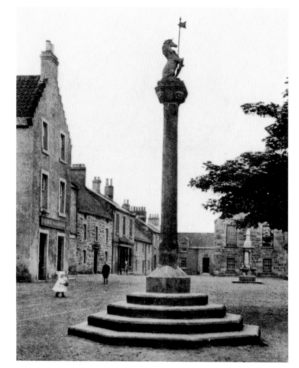

Crail, Mercat Cross

Mercat crosses were a symbol of a town's right to hold a market, an important privilege. It marked the spot where trade was carried out and public proclamations were made. The shaft of the current market cross dates from the seventeenth century. The steps and unicorn date from its restoration in 1887 for Queen Victoria's Jubilee when it was moved to its current location from closer to the tolbooth.

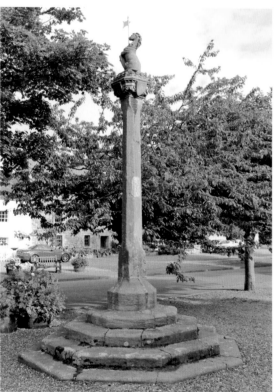

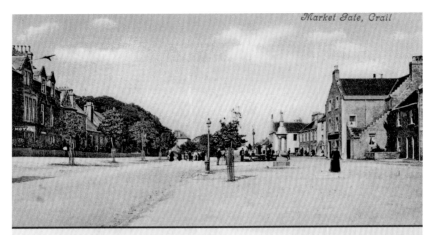

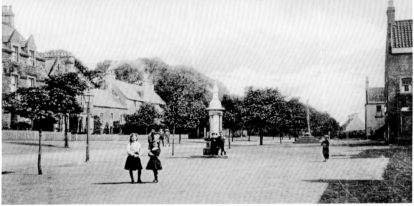

Crail, Marketgate

A much-changed view looking east on the Marketgate, due to the car parking area that occupies this historic part of Crail. The Queen Victoria Jubilee drinking fountain, which is prominent in the older images, was erected in 1897 to commemorate the queen's Diamond Jubilee year. The inscription reads: 'If any man thirst let him come unto me and drink, John.7.37' and 'Presented to his native town by Andrew Mitchell J. P. Glasgow'.

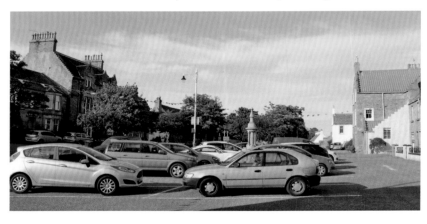

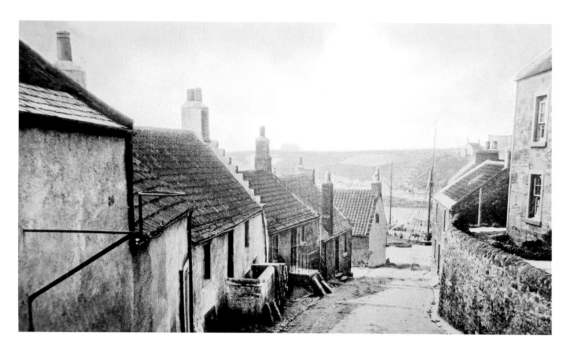

Crail, Shoregate

The steep and charming Shoregate, linking the high street and the harbour, is the oldest street in Crail. It is lined with seventeenth- and eighteenth-century houses displaying well-preserved architectural features – crow-stepped gables, pantiled roofs, harled walls and external forestairs – which characterise the East Neuk fishing villages. Crow-stepped gables are a result of the difficulty of cutting sandstone diagonally. Many of the roofs would originally have been thatched; clay pantiles were originally brought to Scotland as ballast in ships returning from Holland.

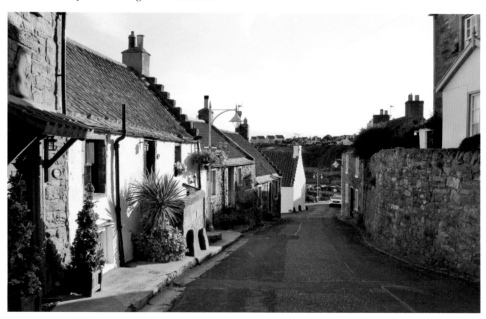

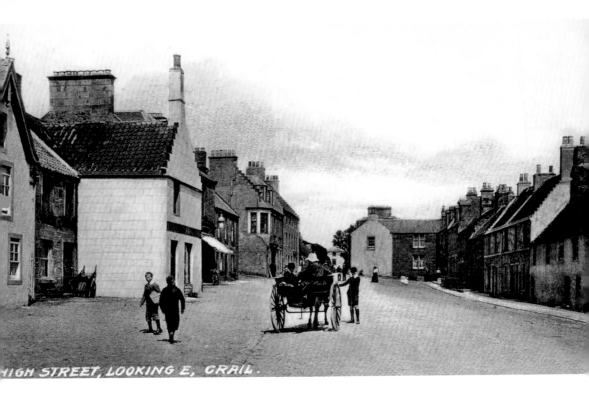

HIGH STREET, LOOKING E, CRAIL.

Crail, High Street

These two remarkably unchanged images are separated by 100 years. The building in the background with the distinctive corner window was Crail's post office.

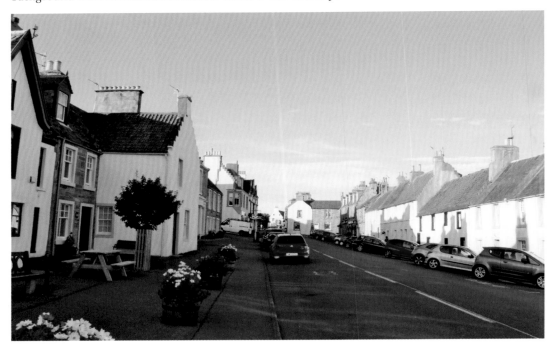

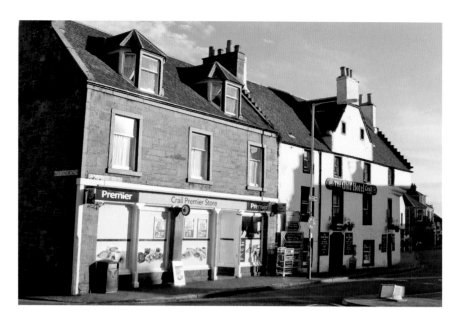

Crail, Golf Hotel

There has been an inn on this site for centuries and the current building with its distinctive corbelled corner dates from the early eighteenth century. The Crail Golfing Society, the seventh oldest golf club in the world, was established in February 1786 at the hotel – Daniel Connoly, one of the eleven original members, was the proprietor.

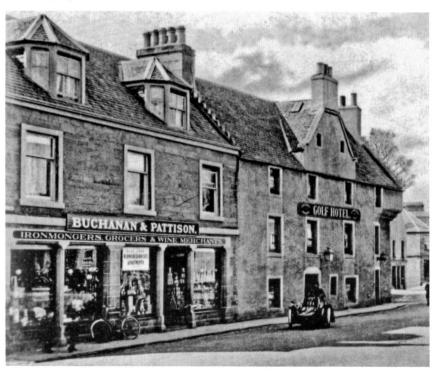

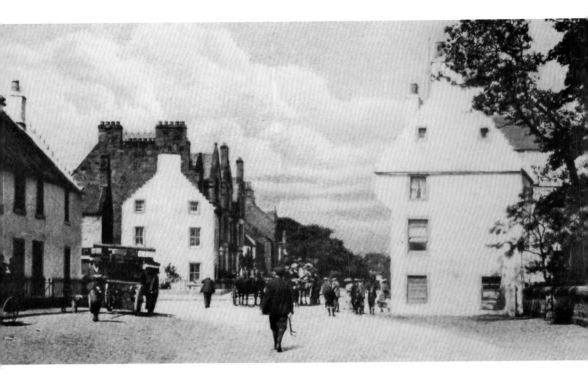

Crail, High Street

A bustling corner of Crail High Street in both of these images. The older image dates from 1905 and shows the gable of a crow-stepped corner building to the left which was demolished in the 1920s and replaced with the building which is now the Crail branch of the Royal Bank of Scotland.

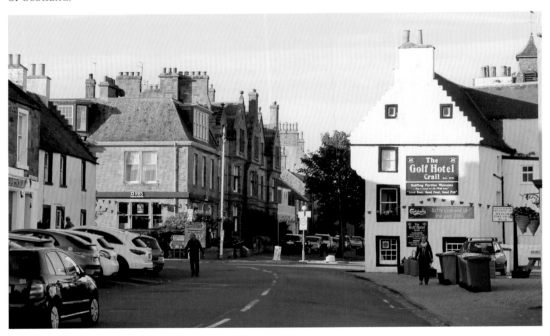

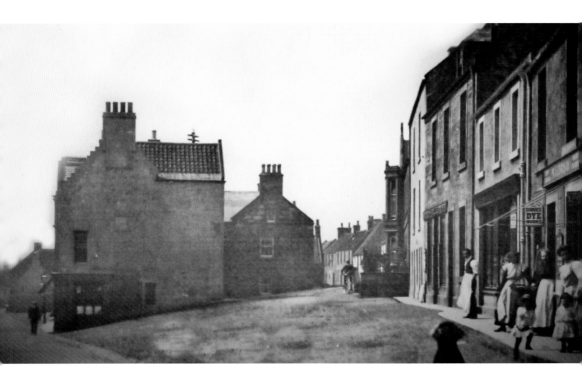

Crail, West Green
A view of West Green from the high street in around 1910. W. Lindsay's grocery shop to the right of the older image looks a busy place and advertises Lyon's Tea and Dundee Dye Works.

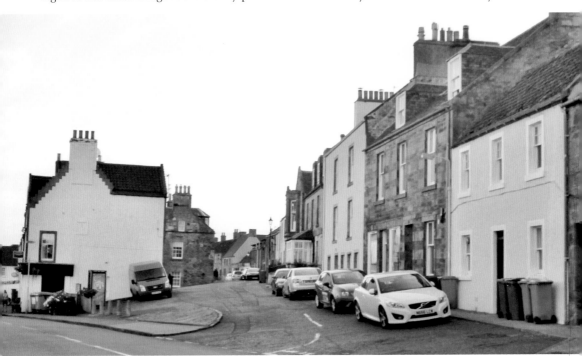

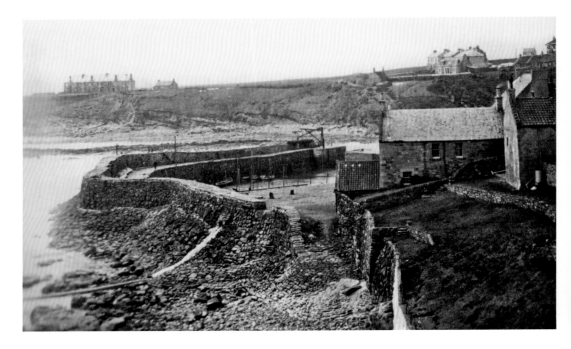

Crail, Maggie Inglis Hole

Apart from some more recent housing development in the distance on the West Braes, the strikingly pretty Crail harbour remains relatively unchanged in these two images separated by over 100 years. The coastal area of the sea at this location is known as Maggie Inglis Hole. This was a spot where individuals suspected of witchcraft were tested by being bound and thrown into the water – if they survived they were in league with the Devil and were executed; if they drowned they were proven innocent.

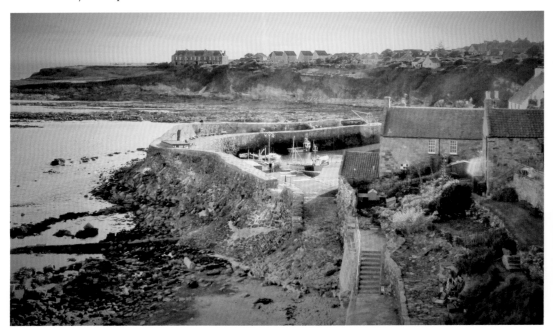

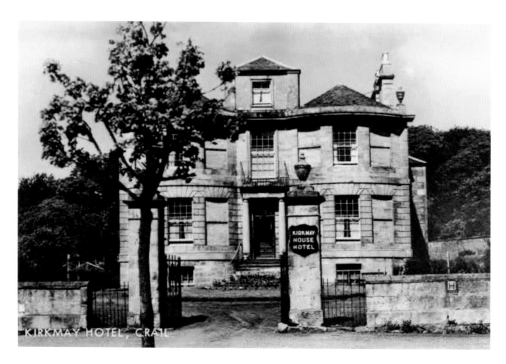

Crail, Kirkmay House

Kirkmay House dates from 1817 and was built for James Inglis, who was the owner of the Kirkmay Estate. The finely detailed Georgian building with its set back double-bow frontage is in unambiguous contrast to its vernacular neighbours. A lintel on the rear elevation, possibly salvaged from an earlier building on the site, is dated 1619, but has been set in the building upside down.

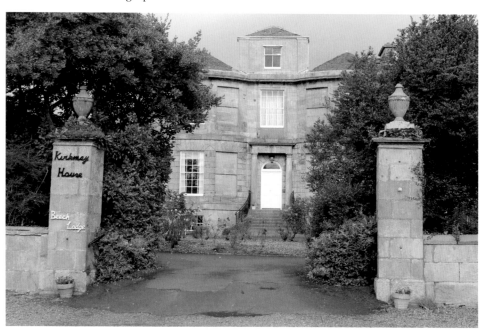

Crail, Victoria Gardens, St Andrews Road

Victoria Gardens and the Crail Community Hall on St Andrews Road. The church opened in 1909 as the United Free Church, became St David's church of Scotland in 1929 and the hall for the parish church in 1954. Victoria Gardens is a small public park which opened in 1914 and includes the Standing Stone of Sauchope, a ninth-century carved stone which was originally sited to the west of Sauchope Farm to the south-east of Crail. The 6-foot-high stone is decorated with Pictish carvings of horsemen on one side and a cross on the other – these are now difficult to decipher due to erosion of the surface.

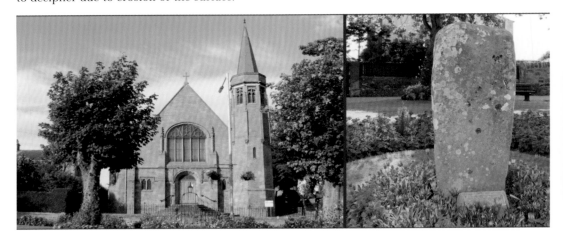

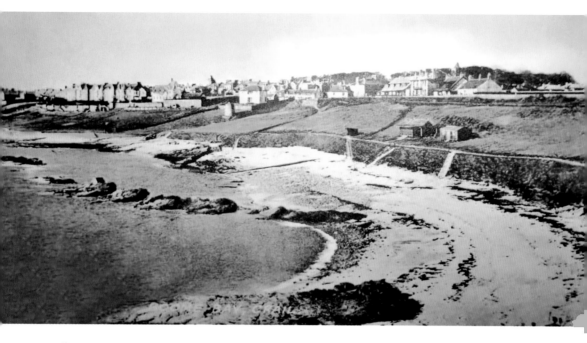

Crail, Roome Bay

Roome Bay is an attractive sandy cove with rock pools to the south-east of Crail, which in August 1968 was the scene of one of the best recorded encounters with ball lightning. Ball lightning is an unexplained occurrence in which luminous, spherical objects appear and may eventually explode. One lady was on the shore when she saw what she described as a rotating ball of light moving towards the beach hut café, which can be seen in the older image. A lady who worked in the café also saw the ball of light and described a cracking sound and bright glare when it exploded. There was also a simultaneous disturbance on the beach from a whirlwind, with deckchairs thrown into the air. Roome Bay was once considered as a potential harbour for boats to replace Crail's historic harbour, which could not accommodate the larger fishing boats that came into use in the nineteenth century.

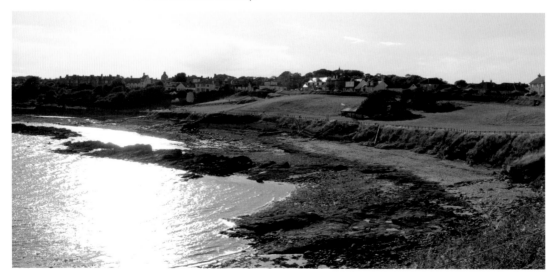

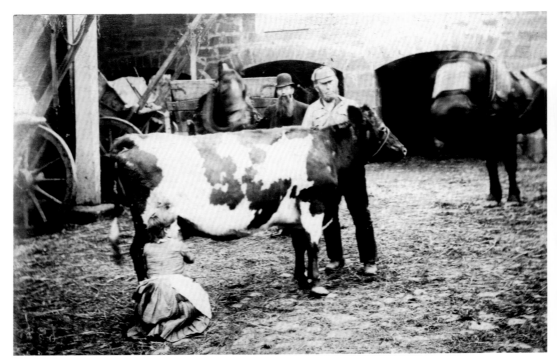

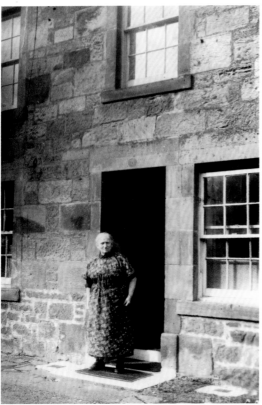

Crail, Troustrie Farm and West Green

The first of these two old family photographs shows Margaret (Maggie) Bonthrone as a young girl milking a cow at Troustrie Farm, near Crail, in around 1895. Maggie was born in 1883, the daughter of Robert Bonthrone and Elizabeth Rollo. At the time of Maggie's birth, Elizabeth worked as a milkmaid at Coalfarm, near Kilrenny where she had been born, and Robert was an apprentice maltster in his father's distillery at St Monans. By 1891, Robert was working as a farm labourer and the family were living at 105 East Pellousie Farm Cottages near Kilrenny. The family then moved from East Pellousie to Troustrie Farm. The other photograph shows Elizabeth Bonthrone (née Rollo), in the 1930s, standing at the door of her home at 5 West Green, Crail – the house that she moved to after retiring from farm work.

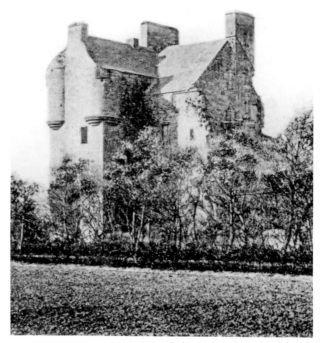

Crail, Balcomie Castle
The original castle at Balcomie
dates back to the thirteenth
century, when it belonged to
the Hay family. In 1526, James
Learmonth of Clatto was granted
the lands of Balcomie. The house
that he built was said to be
capable 'of accommodating a troop
of dragoons, giving every man a
bed, and every horse a stall'. The
castle was visited by Mary of Guise
in June 1538 when she arrived in
Scotland for her betrothal to King
James V at St Andrews. Legend
has it that the castle was haunted
by the eerie whistle-playing of the
ghost of a boy minstrel who was
locked away and starved to death
by his master in the sixteenth
century for disturbing his sleep by
playing the instrument. By the late
nineteenth century the castle fell
into disrepair and was partially
demolished.

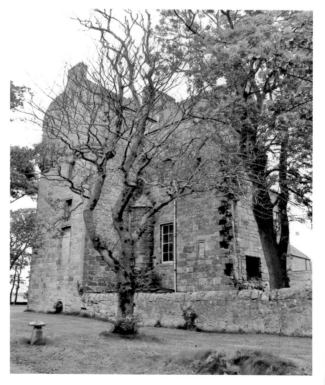

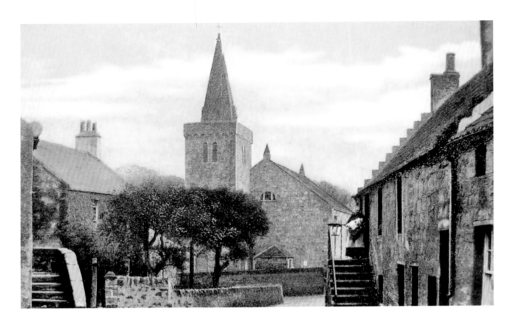

Kilrenny

Kilrenny is a picturesque little village inland from the coast to the north of Anstruther. There is some debate about the derivation of the name Kilrenny. It may be that it comes from the dedication of the church to St Irenaeus or to St Kilringan (Ninian). However, it may also be a corruption of the old Gaelic *Irnaidhe*, meaning 'a prayer', or again from the Gaelic *Cill Reithneach*, meaning 'church of the bracken'. The village was known as Upper Kilrenny, until Lower (or Nether) Kilrenny changed its name to Cellardyke in the sixteenth century. Kilrenny has an attractive collection of well-preserved houses. Agriculture and fishing were the main occupations in the village and most of the cottages were occupied by farm labourers and fishermen. The oldest part of the present Kilrenny church is the fifteenth-century tower, which dominates the village and was a landmark for fishermen. The original church, with the exception of the tower, was demolished in 1806 and the new building erected in 1807/08.

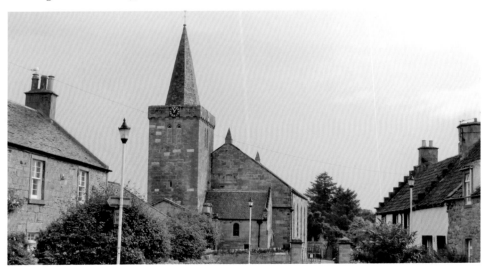

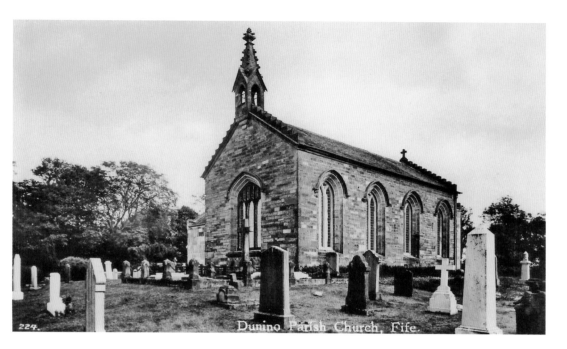

Dunino Church

Dunino is a cluster of houses inland in the East Neuk on the B9131 between St Andrews and Anstruther. The parish church stands in its graveyard amid rich farming land to the east of the Dunino Burn. The church dates from 1826, but early carved stones, one carved with a footprint, in the nearby Dunino Glen indicate that the place has been a religious site for thousands of years. The fine Scottish Baronial Stravithie House, dating from 1897, and former water-powered corn mill Stravithie Mill are also in Dunino.

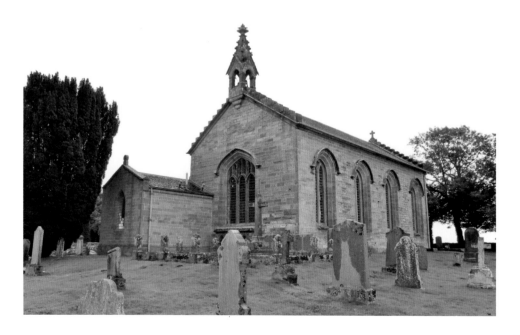

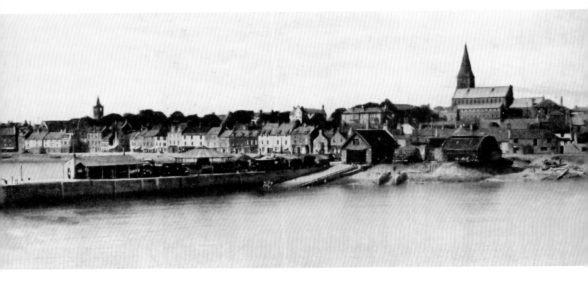

Anstruther from Lighthouse

Anstruther is the largest of the East Neuk villages and has a long association with fishing. The town was originally two separate communities – Anstruther Easter and Anstruther Wester, which developed on opposite sides of the Dreel Burn. In the nineteenth and early twentieth centuries, it was the main herring port on the Forth – in 1840, there was a fleet of 100 fishing boats and whaling from the town also began around this time. A new east pier, which was built in the 1860s, was damaged by storms in 1870 and after further storm loss it was finished in concrete in 1873 – making it the largest fish harbour in Fife. After a record catch in 1936, the herring shoals mysteriously declined in the Forth, the industry effectively disappeared by 1947 and Anstruther's importance as a working harbour rapidly deteriorated.

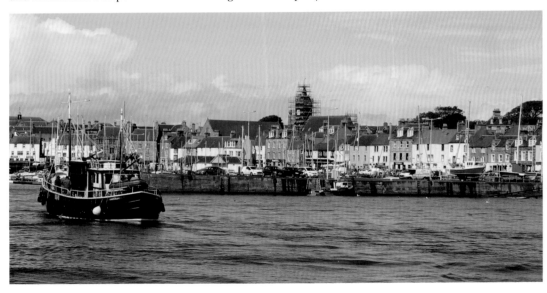

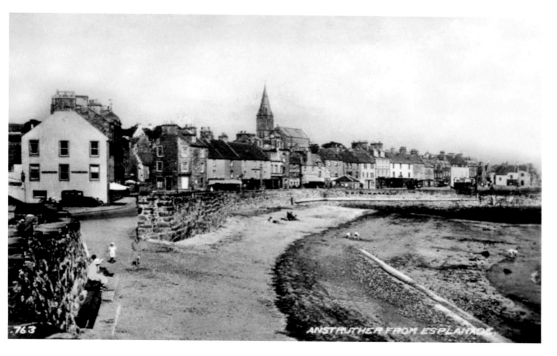

Anstruther from Esplanade

The enduring quality of Anstruther is reflected in these relatively unchanged images of Shore Street. The ancient form of the town name is Kynanstruther – 'struther' means a place lying in a valley.

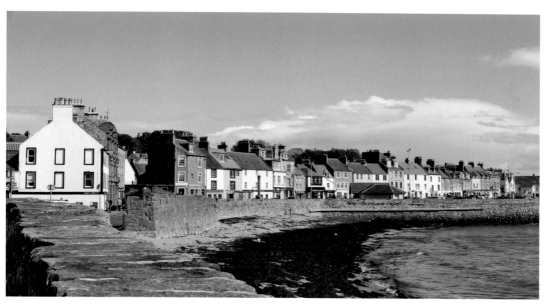

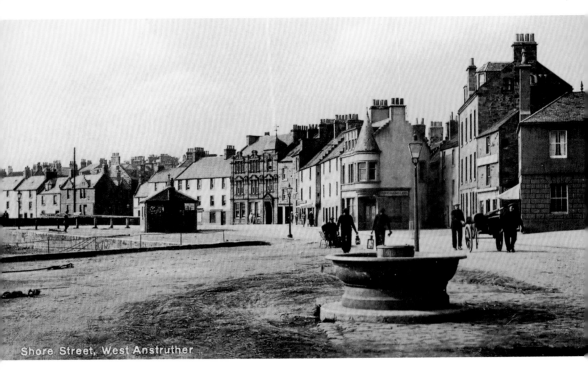

Shore Street, West Anstruther

Anstruther
The feature in the foreground of the older image is the Queen Victoria Jubilee Fountain, which was removed in 1925.

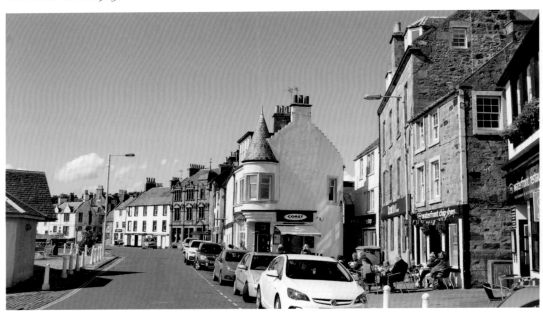

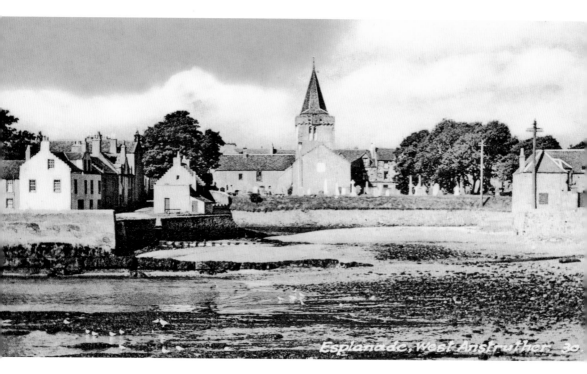

Anstruther, Parish Church and Esplanade
The Esplanade is a broad street which runs down to the sea wall and is lined with eighteenth-century harled and painted houses. The parish church was rebuilt around 1846 and retains its sixteenth-century steeple.

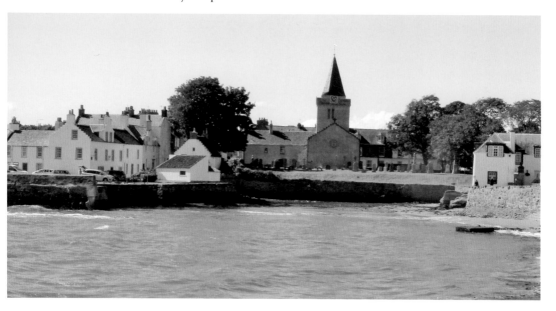

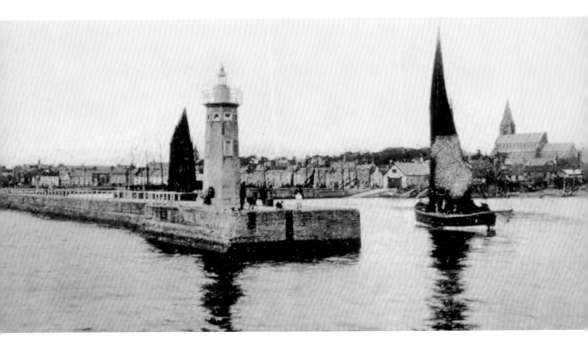

Anstruther Lighthouse

The 29-foot-high octagonal Chalmers lighthouse at the end of the breakwater on Anstruther pier was erected in 1880, the centenary of the birth of Thomas Chalmers, one of the town's most renowned sons. His father, John, was a merchant and provost of Anstruther. An exceptionally gifted boy, he went to St Andrews University at the age of eleven to study mathematics and natural philosophy, before turning to theology.

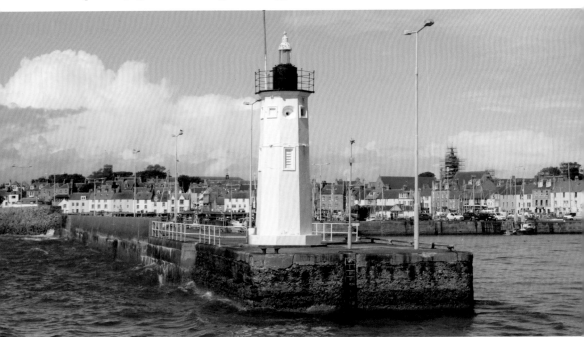

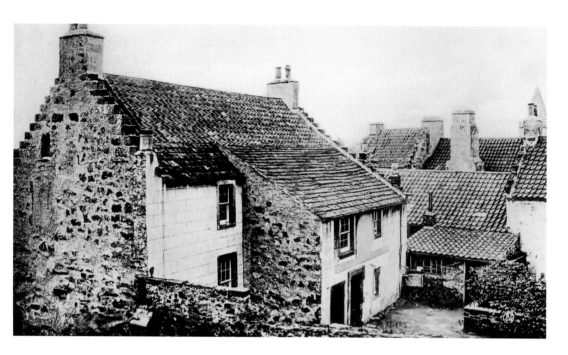

Anstruther, Chalmers House, Old Post Office Close

This eighteenth-century house was the birthplace of Thomas Chalmers (1780–1847), who is renowned as 'Scotland's greatest nineteenth-century churchman'. In 1815, he became minister of the Tron parish church in Glasgow, where his powerful sermons attracted large crowds and brought him great fame. In 1823 he was appointed to the chair of moral philosophy at St Andrews University and in 1838 he became professor of theology at the University of Edinburgh. Chalmers led a third of the ministers out of the established church to form the Free Church of Scotland in the Disruption of 1843.

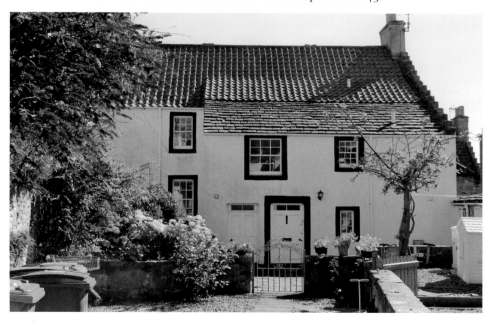

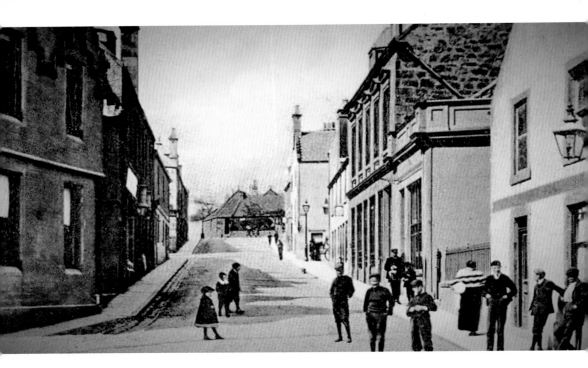

Anstruther, Rodger Street
A group of locals are taking an interest in the photographer in the older image looking north on Rodger Street. Apart from the parked cars, little has changed in the 100 years that separates these images.

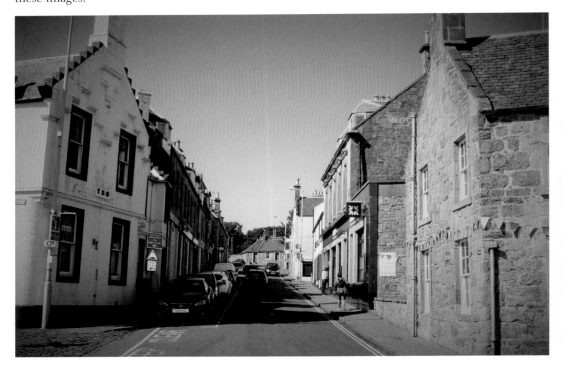

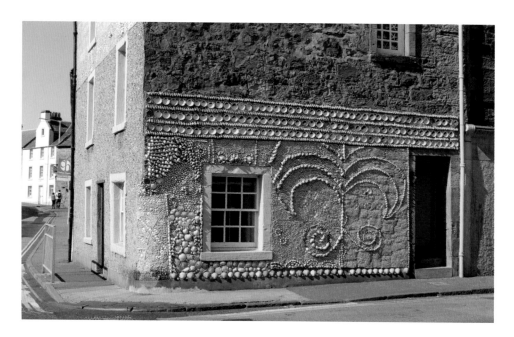

Anstruther Shell House

Buckie House, at the junction of High Street West and Elizabeth Place, dates from the seventeenth century and is known as the Shell House due to its elaborate decoration with scallop shells and whelks, or 'buckies'. The shell embellishment was the work of Alex Batchelor in the nineteenth century. Batchelor charged visitors to view a room in the house which was decorated as a shell grotto and reputedly displayed a coffin covered with shells. Robert Louis Stevenson visited the house as a young boy and noted in his journal that it was the home of an 'agreeable eccentric'. The Anstruther Shell House may have been the inspiration for another exuberant shell creation in Leven's Seagate.

THE BUCKIE BUS AND GARDENS, LEVEN.

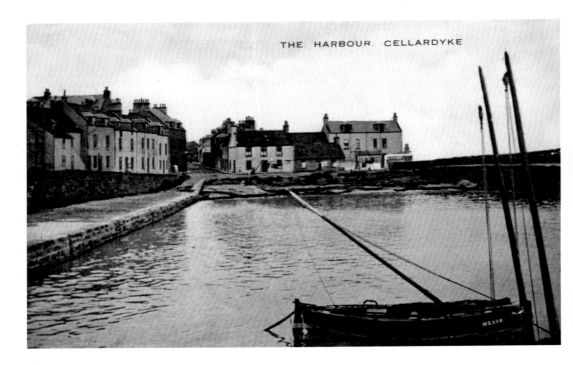

Cellardyke Harbour Looking North

Cellardyke was known as Lower Kilrenny until the sixteenth century. It was also known as Sillerdyke, Silverdicks and the evocative Skynfischtoun. Sillerdyke is said to be a reference to the silvery reflection of the sun from fish scales on nets drying on the dykes around the harbour, and Cellardyke from cellars used to store the fish. The harbour is known locally as Skinfast-haven. In 2006, Cellardyke became the centre of worldwide media attention when a dead swan that was found floating in the harbour was confirmed as the first instance of avian influenza in Britain.

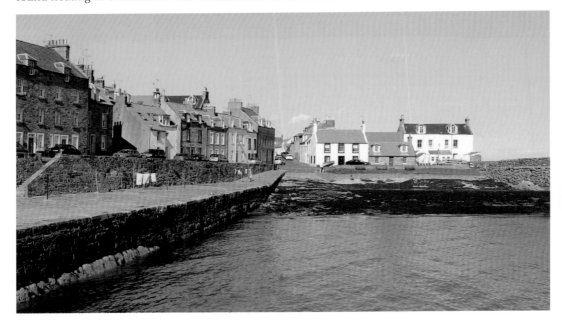

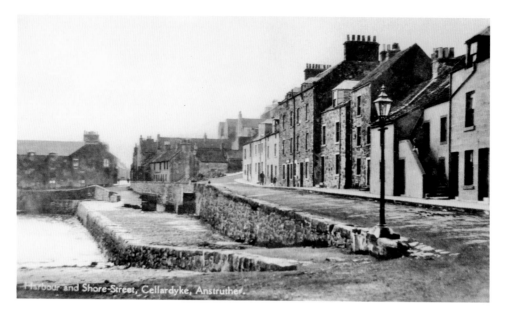

Harbour and Shore-Street, Cellardyke, Anstruther.

Cellardyke Harbour Looking South

John Beaton of Kilrenny, the local laird, provided a safe anchorage and a pier in 1579. A market cross was erected and coat of arms adopted – a crewed fishing boat with a hook dangling in the water. The Latin motto of the town, *Semper Tibi Pendiat Hamus*, translates as, 'May a hook always hang for you.' In the mid-nineteenth century, Cellardyke was a thriving place with more than fifty boat owners and skippers. The introduction of larger fishing boats, and the opening of a railway station at Anstruther in 1863, resulted in the extension of the facilities at Anstruther to form the Union harbour and the winding down of fishing at Cellardyke. The east pierhead collapsed during a storm in January 1986 and reconstruction was completed in 2002.

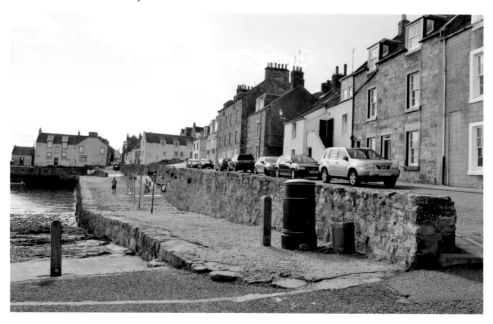

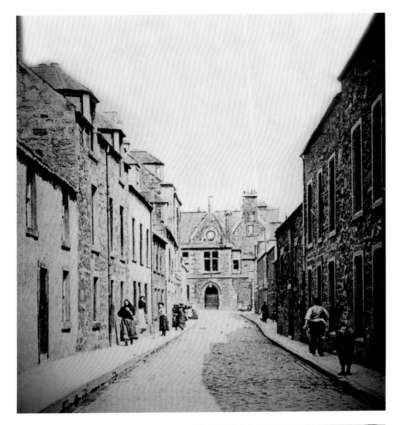

Cellardyke Town Hall
The Baronial Cellardyke Town Hall was opened on 19 September 1883 and replaced an earlier tolbooth, which dated from 1624. An inscribed stone on the building reads: 'Erected by Stephen Williamson and David Fowler for Municipal and other Purposes in this their Native Town A.D. 1883.' Williamson was born in Cellardyke in 1827 and went on to co-found a prosperous shipping company. He was also the Liberal MP for St Andrews from 1880 to 1885. The mercat cross, which dates from 1692, is now built into the wall to the right of the entrance. The building was taken over by local residents in the 1980s when it was closed by the council. A substantial sum was raised for its refurbishment and it reopened in 1995 as a museum.

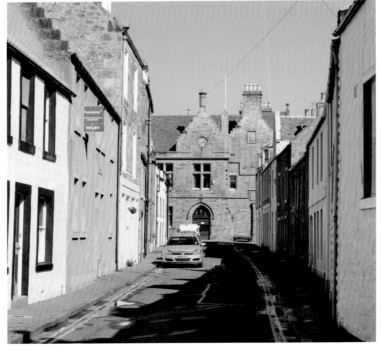

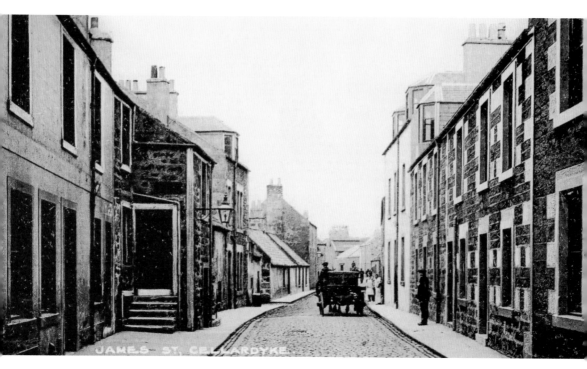

Cellardyke, James Street

Cellardyke's long and winding main street was not divided into three separately named streets until after 1871. James Street, John Street and George Street were named after local councillors: James Fowler, Provost John Martin, and George Sharp.

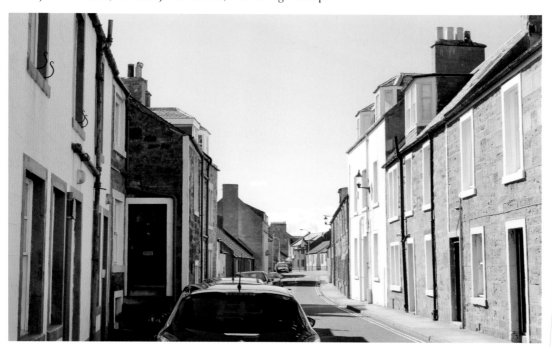

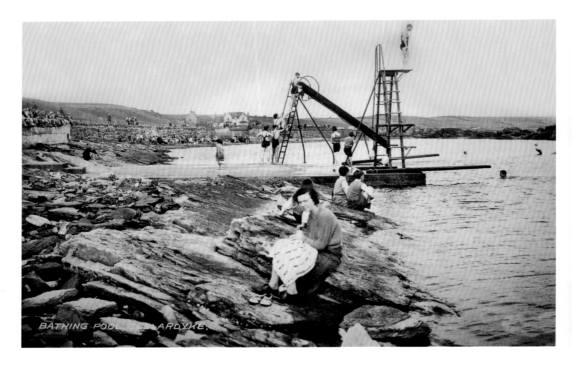

Cellardyke Bathing Pool

The tidal bathing pool at Cellardyke was developed from the natural rock outcrops of the seashore in the 1930s by local volunteers. It was known as the Cardinal's Steps after Cardinal Beaton of St Andrews. The pool was refilled each high tide and provided a chilly bathing experience. It was equipped with a slide, diving platform and bathing huts, in the area now occupied by the caravan site. Maintenance of the pool ceased in the 1990s and it was slowly eroded by the sea. Currently the pool is being used as an experimental site by the University of St Andrews – nineteenth-century cannons have been placed in the pool to study their rates of corrosion.

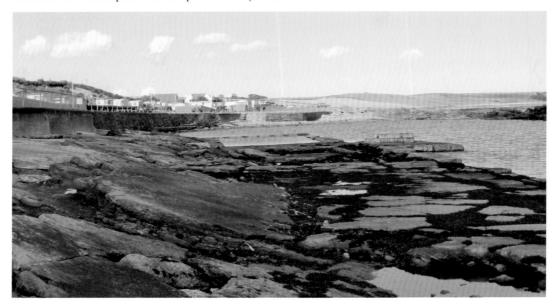

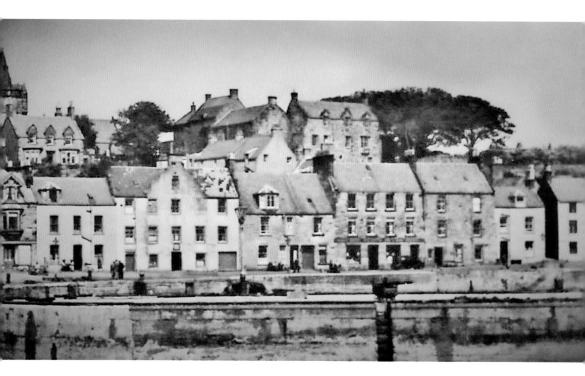

Pittenweem, East Shore
Pittenweem developed as a fishing village around the priory and became a royal burgh in 1541. Its prosperity was built on the production of salt using coal from local pits and on agricultural produce.

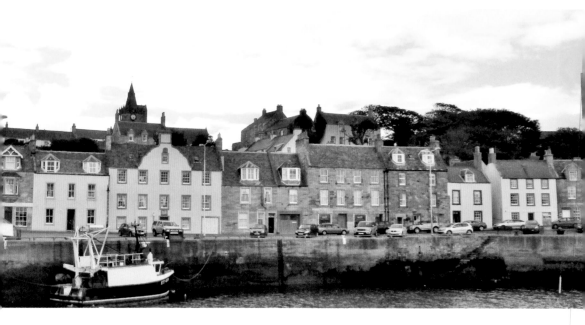

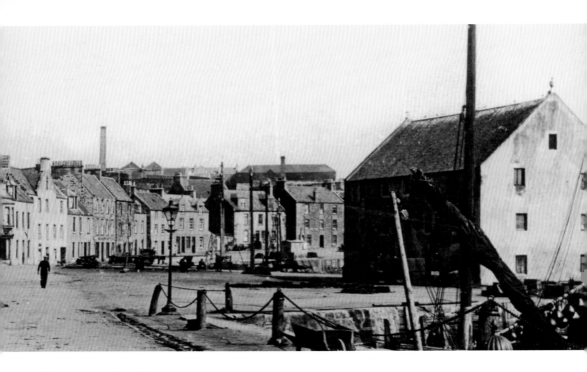

Pittenweem, East Shore

Pittenweem harbour developed from the sixteenth century. Sir John Anstruther expanded the harbour in the latter part of the eighteenth century to ship the coal and salt being produced on his land. The mines and salt pans were linked to Pittenweem harbour by a waggon way. Pittenweem harbour is now the main base for fishing in the East Neuk. The Old Fish Market, built in about 1800, sits on a prominent corner of the harbour.

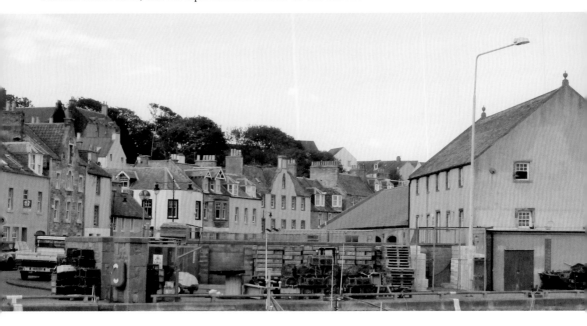

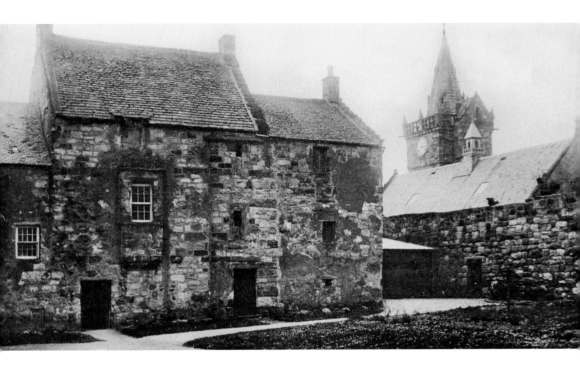

Pittenweem Priory

Pittenweem Priory was established in the thirteenth century when the Augustinian monastery relocated from the Isle of May. The fortified east gatehouse and the 'Great House', one of Scotland's best-preserved late medieval houses, which served as the dormitory and refectory for the prior and monks, survive from an extensive fifteenth-century reconstruction of the priory buildings. The buildings ceased to be used as a priory after the Reformation in 1560.

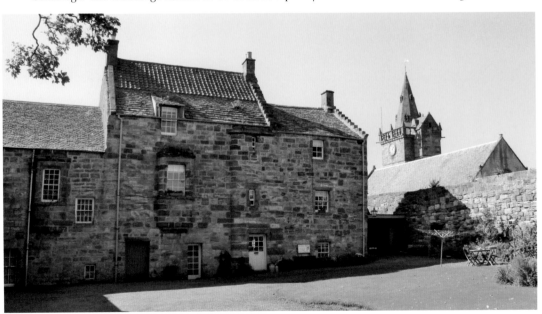

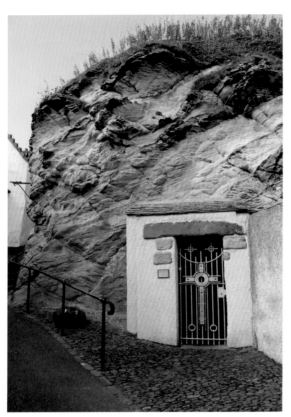

Pittenweem, St Fillan's Cave, Cove Wynd

Pittenweem, the place of the cave, takes its name from St Fillan's Cave on the steep Cove Wynd leading from the high street to the harbour. The cave, formed naturally by erosion, is particularly associated with the eighth-century St Fillan, who is said to have lived for a time as a hermit there. With the Reformation, worship of saints was discouraged and the cave was put to various uses – it was used as a prison, for concealing smugglers' contraband, as a store room for local fishermen and as a rubbish tip. It was rediscovered in the early twentieth century, apparently when a horse fell down a hole, was reconsecrated for religious use in 1935 and fitted out as an atmospheric small chapel dedicated to St Fillan in 2000.

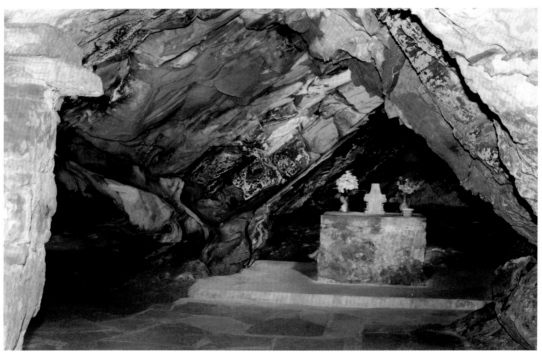

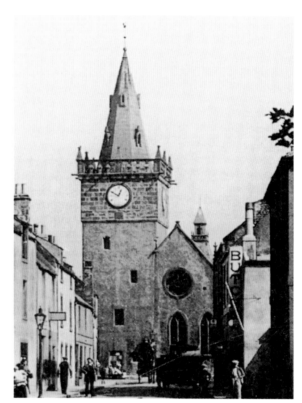

Pittenweem Parish Church
The east end of the Pittenweem high street is closed by the gable of the parish church. Parts of the building date back to the thirteenth century and originally formed part of Pittenweem Priory. The tower was originally the Pittenweem tolbooth, which dates from 1588. Pittenweem's mercat cross now stands against the church tower.

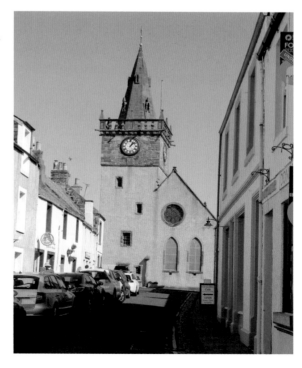

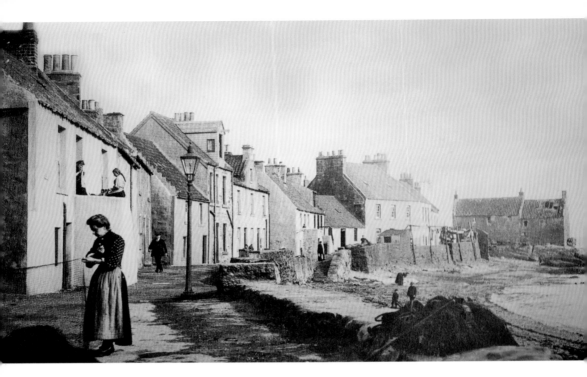

Pittenweem, West Shore

Remarkably unchanged views in the 100-year time span that separates these two images of Pittenweem's West Shore. The houses on the shore date mainly from the eighteenth century and the large building to the rear of the line of houses was a late nineteenth-century cooperage, which has been redeveloped for housing.

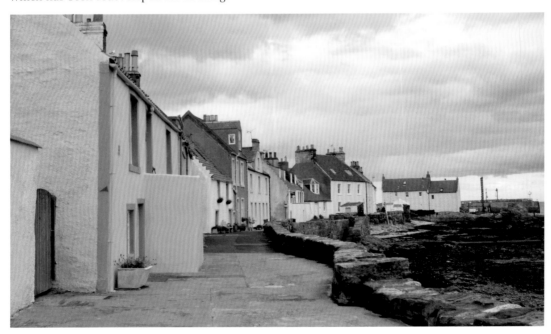

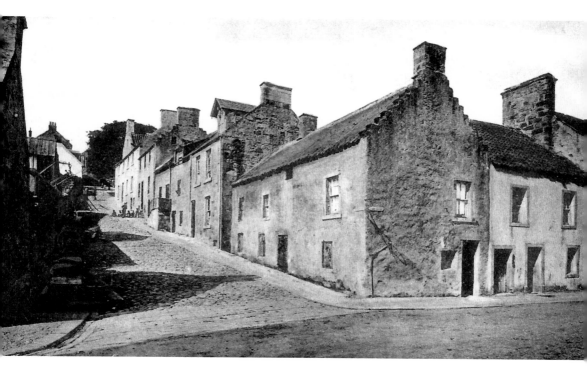

Pittenweem, Water Wynd
The picturesque ancient buildings at the foot of Water Wynd were removed in the early twentieth century as part of a civic improvement programme.

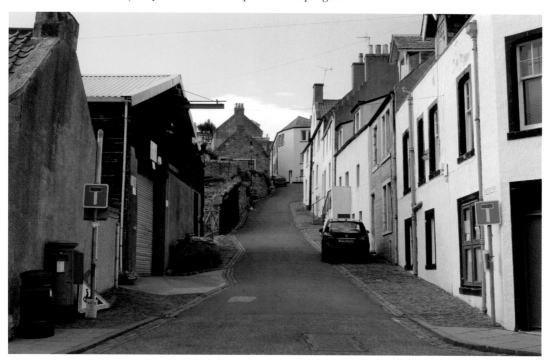

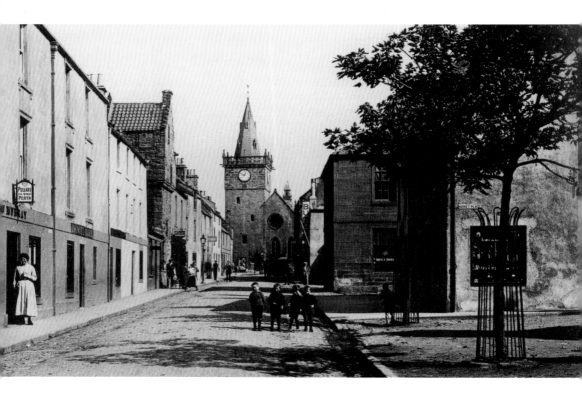

Pittenweem, High Street

Pittenweem's High Street, with its wide marketplace, lies above and behind the harbour. The stone building with the pantile roof to the left of the images is the sixteenth-century Kellie Lodging which was the town house of the Earls of Kellie.

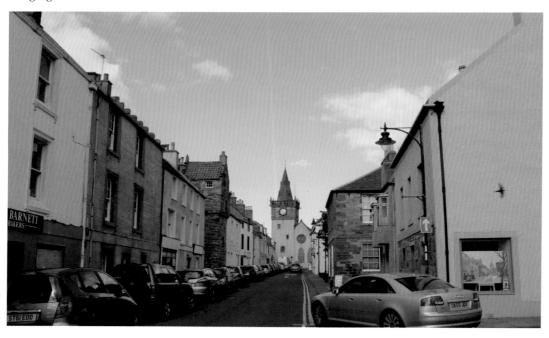

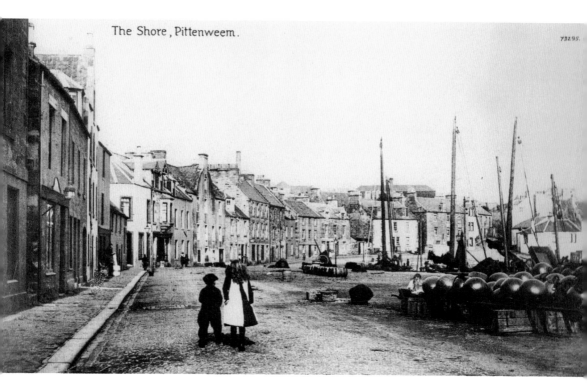

Pittenweem, the Shore

This view along the Shore at Pittenweem is now partially blocked by the fish market building, which dates from 1994. A stack of drift net buoys, which were used to allow the fishing nets to hang vertically in the water, can be seen in the older image.

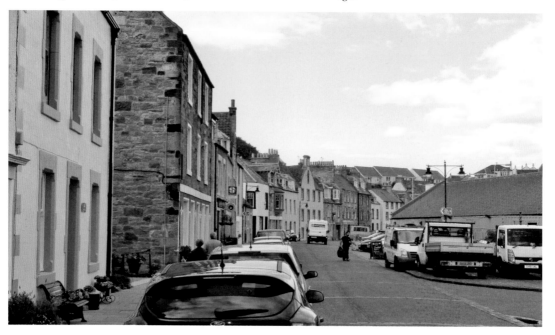

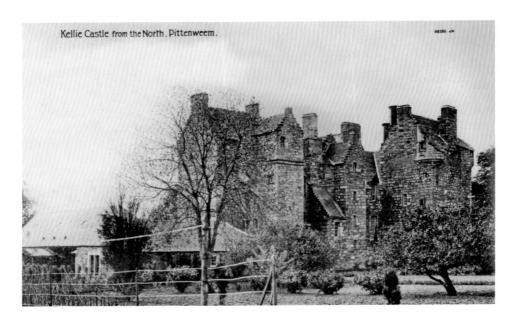
Kellie Castle from the North. Pittenweem.

Kellie Castle

There are records of a castle at Kellie from the mid-twelfth century and parts of the present structure date back to the fourteenth century. In 1613 Sir Thomas Erskine took over the estate. Erskine had saved the life of King James VI and the king stayed at Kellie in 1617, shortly before Erskine was appointed Earl of Kellie. The 5th Earl was a Jacobite and is said to have evaded capture after Culloden by hiding in a hollow tree in the garden for the entire summer of 1746. The castle was abandoned and fell into disrepair and by 1860 some of the grand rooms were in use as a barn. In 1878, Kellie Castle was leased to the Lorimer family. Hew Lorimer, the renowned sculptor, took over the lease in 1937 and later purchased the estate. In 1970, Kellie Castle was purchased for the nation by the National Trust for Scotland.

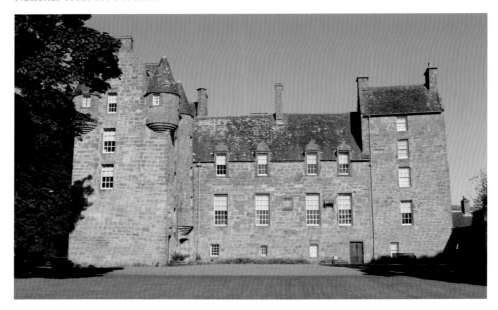

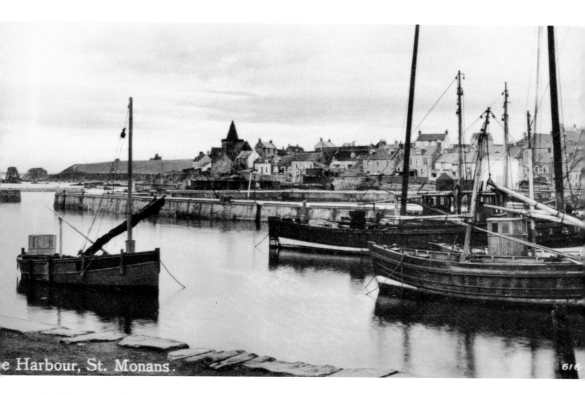

e Harbour, St. Monans.

St Monans Harbour

Once known as Inverin or Inverie, St Monans (or St Monance) takes its name from the legendary Saint Monan. The original jetty at St Monans is recorded as early as 1590 and lay close to the position of the current central pier. A west pier was built by 1858 and the Alexandra Pier in the 1860s. The harbour was extensively rebuilt in the 1880s, and deepened in 1902–5. In 1900, there were over 100 fishing vessels and over 400 fishermen at St Monans; at times there were so many boats in the harbour that it was possible to walk from one side of the harbour to the other using their decks. The fishing industry declined after the Second World War and today few craft fish from the harbour.

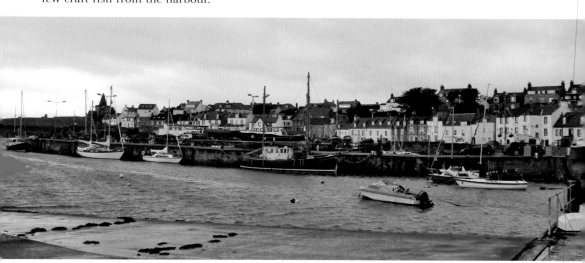

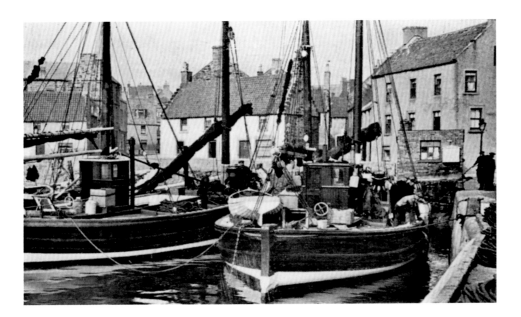

St Monans Harbour

Fifies were a local design of two-masted boats which had a distinctive straight bow and stern, and a large foresail. They were mainly used to follow the herring shoals far out into the North Sea using drift nets. They sat low in the water, were fast and required considerable skill to handle in heavy weather. They were undecked, which left plenty of space for hauling the nets and carrying home large amounts of fish. Many of the East Neuk fishing villages had boatbuilding and repair yards. One of the best known was James Miller & Sons Ltd of St Monans, which was renowned worldwide. The company was established in St Monans in 1779 and specialised in fishing boats, building over 100 Fifies. From the 1920s, the company also built yachts and boats for the navy. The yard was modernised and extended in the 1980s for the construction of large steel fishing boats, but closed in 1995 due to dwindling orders.

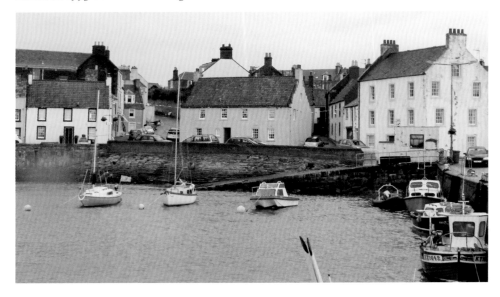

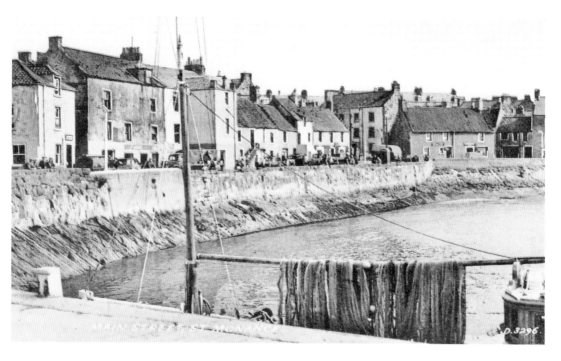

St Monans, Mid Shore

Natives of St Monans are known locally by the colourful sobriquet 'Simminancers'. Fishing has been the chief employment for centuries and the motto of the town is *Mare Vivimus* – 'We Live by the Sea'. St Monans has no high street and the town is focused on the line of old houses at the sea's edge. Mid Shore in St Monans is a broad street of eighteenth and early nineteenth-century houses which follows the line of the harbour wall. Some of the houses are roofed with pantiles, while others have tall, chimney-headed gables to the shore, and are whitewashed, with contrasting painted margins round the windows.

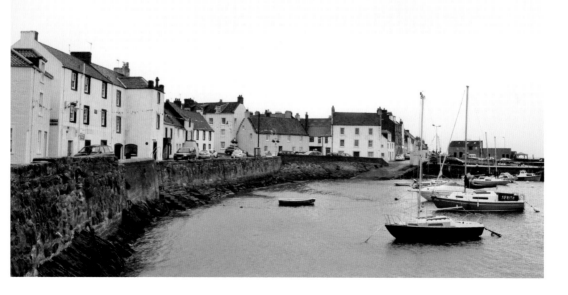

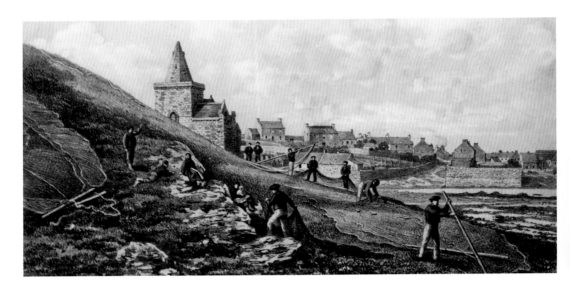

St Monans Parish Church

St Monans parish church is dramatically situated on a cliff top to the west of the village and right on the shoreline – it is the closest church to the sea in Scotland. The roots of the church date back to the ninth century, when a shrine was built to St Monan. A church was built in 1265/67 in close proximity to the shrine. The present form of the building dates to the mid-fourteenth century, when King David II commissioned Sir William Dishington of Ardross to build the church as an offering to St Monan. Legend has it that King David was wounded by two arrows at a battle in 1346, and one of the arrows could not be removed until he made a pilgrimage to the shrine of St Monan. Another story tells how the king vowed that he would build a church to St Monan when his boat was caught in a violent storm on the Forth. St Monan's Well, to the east of the village, was also believed to have healing properties and attracted pilgrims.

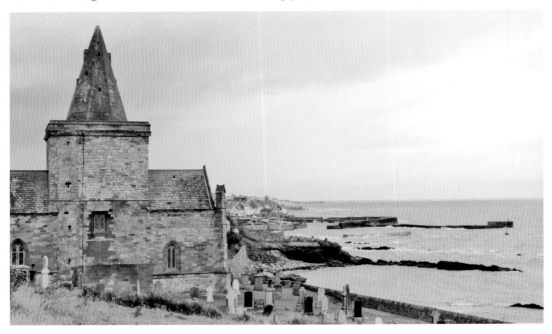

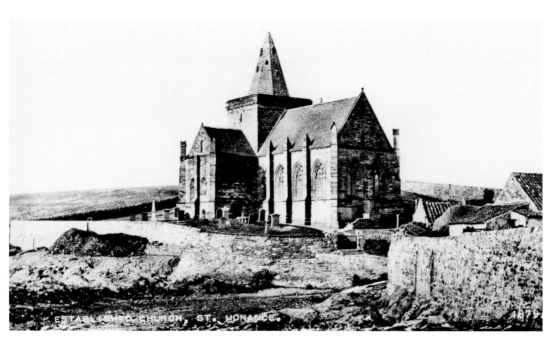

St Monans Parish Church

St Monans church was badly damaged in a naval attack by the English in 1544, fell into disrepair in the eighteenth century and was restored in 1826. The church bell at one time was hung from a tree in the graveyard, but was regularly removed during the fishing season for fear of frightening away the fish.

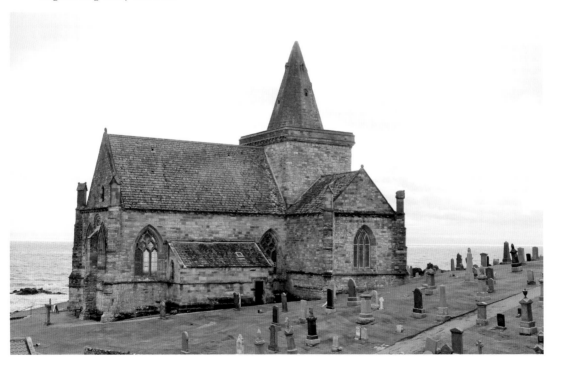

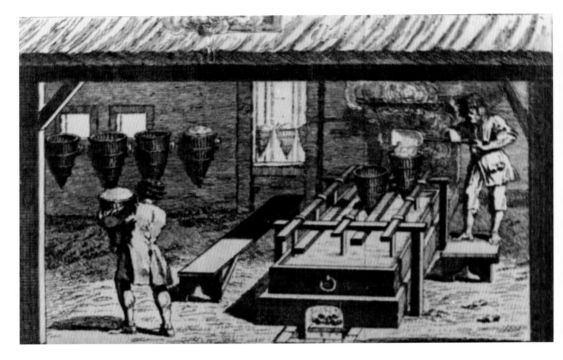

St Monans, Windmill and Salt Pans

The salt pans at St Monans were established by Sir John Anstruther and the Newark Coal Company between 1772 and 1774. The salt-panning process required large quantities of coal – horse-drawn wagons running on wooden rails linked the local coal mines with the salt works, and with Pittenweem. Salt water was pumped by a wind-powered engine into a shallow iron pan, a coal fire was lit beneath it and the brine boiled to produce salt. Each boiling cycle took 24 hours and when operating at full capacity, the nine pan houses required about 10,000 gallons of water per day. The windmill, which was used to pump seawater from a reservoir on the foreshore for distribution to the salt pans, is a distinctive local landmark. The salt pans ceased production in 1823.

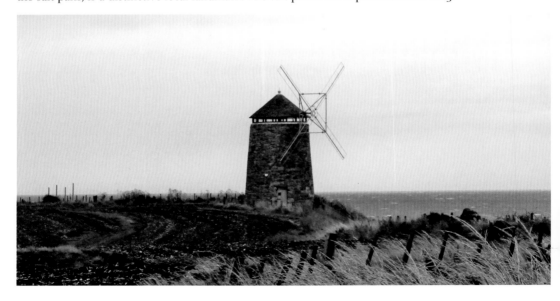

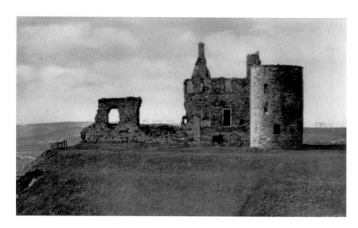

Newark Castle

The striking ruins of Newark Castle, also known as the Castle of St Monans, stand in an outstanding location perched on a clifftop just outside of St Monans. In the mid-thirteenth century, Sir Alan Durward built a castle on the site to take advantage of its defensive locations and Alexander III spent part of his childhood at the castle, as guest of the Durwards. Extended and improved in the fifteenth century and seventeenth century, much of the castle has been lost to coastal erosion over the centuries. There has been a substantial amount of deterioration in the structure in the time period between the older and newer images.

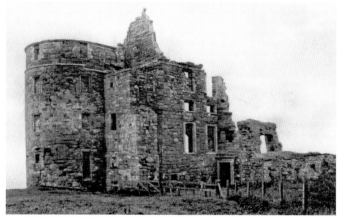

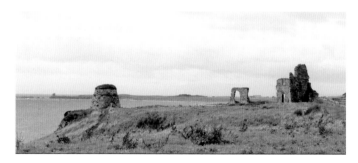

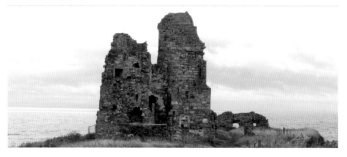

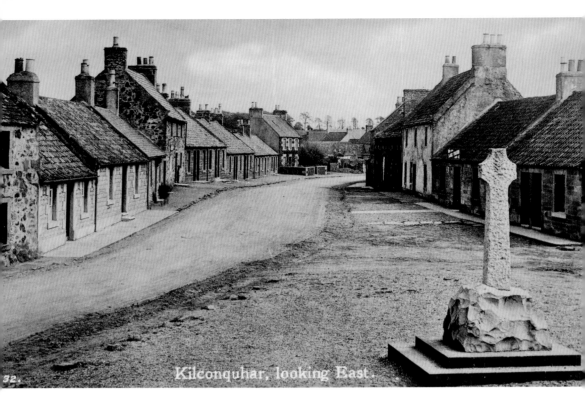

Kilconquhar, looking East.

Kilconquhar

Kilconquhar (pronounced 'Kinuchar') developed on the shores of Kilconquhar Loch as the estate village for Kilconquhar Castle. It takes its name from the Gaelic *Cill Conchubair*, meaning the 'church of Conquhar' – St Conquhar was an early Scottish saint who established a chapel in the 600s. The eighteenth-century inn still maintains the old name of the village Kinneuchar. In the eighteenth century the village was a weaving centre.

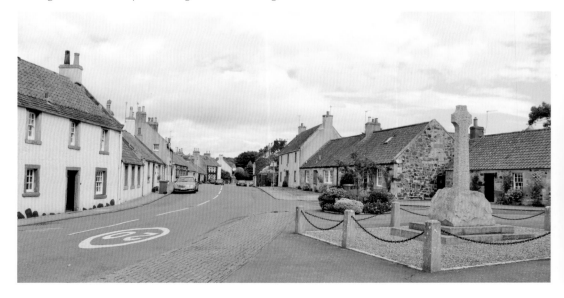

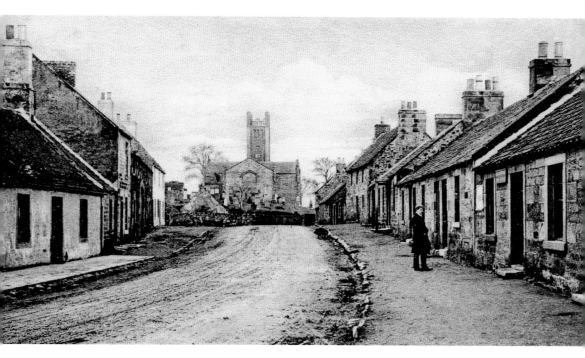

Kilconquhar Parish Church

Kilconquhar parish church stands on a raised knoll at the west end of the village and its massive 78-foot-high pinnacle tower, an unusual feature for a small parish, is a major local landmark. The present church dates from 1819–21 and is a large-scale copy of a design for Cockpen parish church in Midlothian. Fragments of an earlier Kilconquhar church lie in the churchyard. A badly eroded effigy of a knight in armour in the graveyard is known locally as Jock o'Bucklevie.

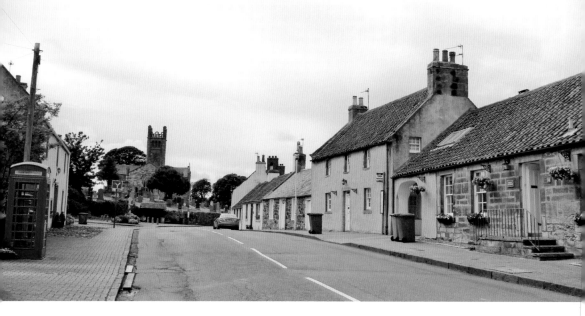

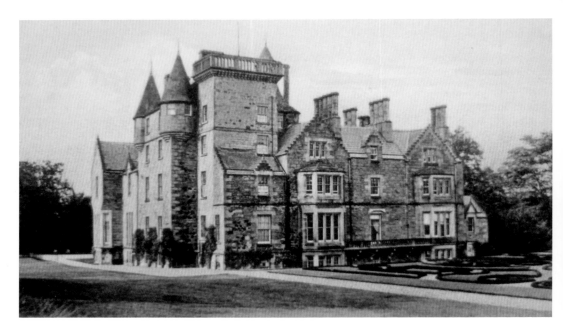

Kilconquhar Castle

Kilconquhar Castle was formerly owned by the Adams of Kilconquhar. The building has its origins in the late 1500s. In the 1830s it was turned into a Baronial mansion by the architect William Burn. The castle was badly damaged by a fire in 1979, and in recent years has been developed as the centre of a self-catering holiday resort.

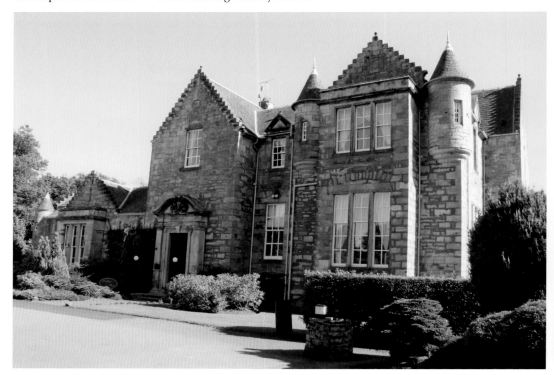

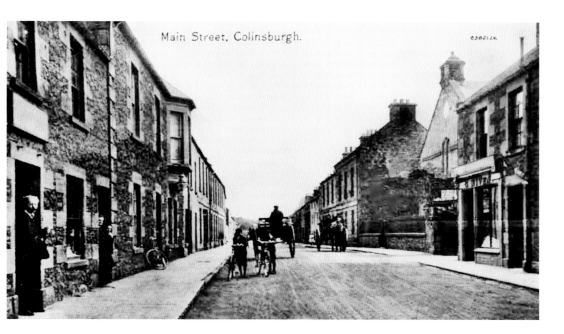

Main Street, Colinsburgh.

Colinsburgh

The only significant change in the 100 years that separates these images is the impact of the car. Colinsburgh was founded in 1705 by Colin Lindsay, 3rd Earl of Balcarres (1652–1722). The Lindsays owned the Balcarres Estate, to the north of Colinsburgh from 1587, and built Balcarres House in 1595. Lindsay was a Jacobite; he was forced into exile in Holland in 1689/70 and was placed under house arrest after the 1715 rebellion. Lindsay established Colinsburgh to provide homes for his Jacobite supporters. Colinsburgh became a Burgh of Barony in 1686 and was an important post town for stagecoach services. The shop in the left foreground was the post office.

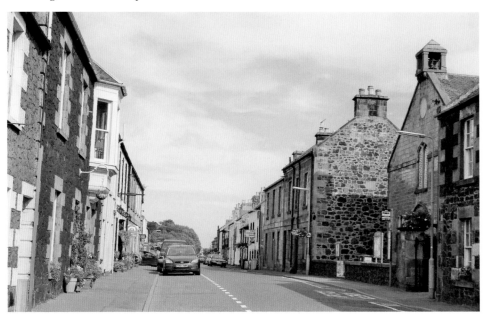

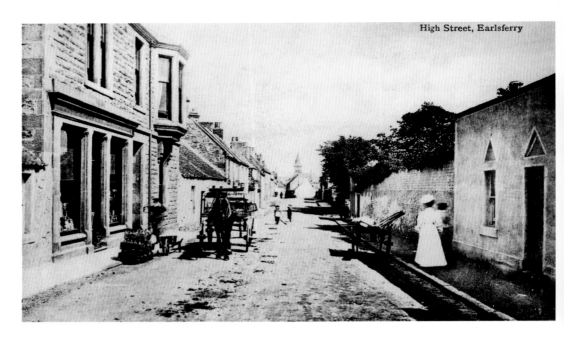

Earlsferry

Earlsferry is much older than Elie. The town was made a Royal Burgh by Robert II in 1373 and James VI noted that Earlsferry was 'old beyond the memory of man' in a Royal charter of 1589. Earlsferry takes its name from the ancient ferry across the Forth which linked North Berwick and land owned by the Earls of Fife. Its location took advantage of the shortest crossing and the natural harbour provided by the wide sandy bay. Legend has it that MacDuff, the Earl of Fife, crossed the Forth in 1054 while fleeing from Macbeth. The ferry was much used by pilgrims heading for the shrine of St Andrew at St Andrews from as early as the eighth century.

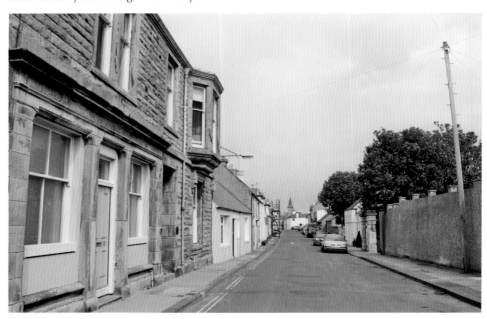

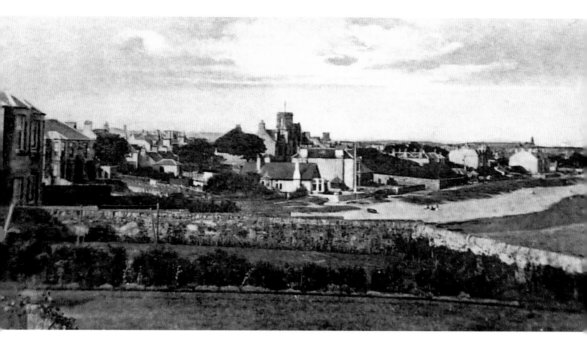

Earlsferry from Chapel Green

The harbour at Earlsferry, at the western end of the bay, was shallow and only suitable for landing foot passengers, while the Elie side of the bay provided deeper water and shelter for larger vessels. The Reformation brought an end to pilgrimage and the importance of the ferry. Earlsferry then relied on fishing and weaving until those declined by the end of the eighteenth century. Elie then became the more prominent harbour. The arrival of the railway in 1863 boosted Earlsferry's attraction as a seaside resort. The separate burghs of Elie and Earlsferry were united in 1930 by the Local Government Act of 1929.

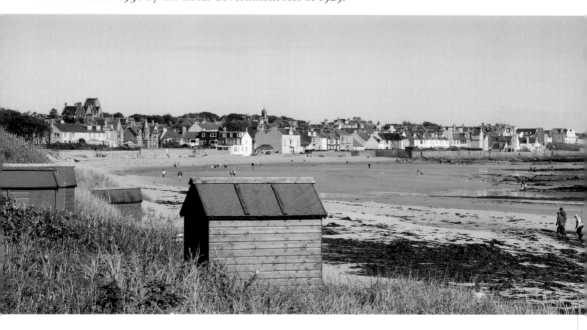

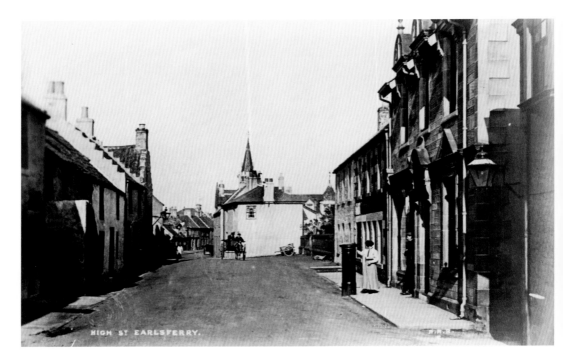

Earlsferry, High Street

There has been little architectural change in these views of Earlsferry High Street, although cars have replaced the horse-drawn carriage and handcart. A lady is posting a letter in the pillar box which stood outside the post office in the older image. Earlsferry's post office, which opened in 1904, occupied the building beside the pillar box. The forestair on the left of the images is one of the few survivors from a late nineteenth-century improvement programme in the town.

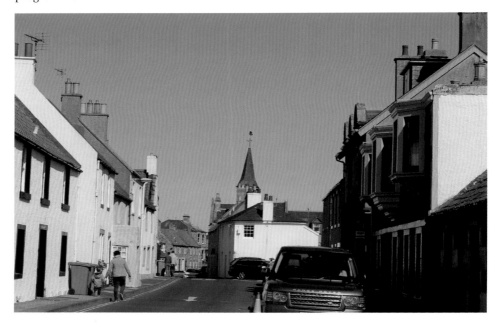

Earlsferry Townhouse

Earlsferry Townhouse was built over the period 1864–74 and provides a focal point for the town. It replaced an older building which was in a poor condition. It was designed by local architect John Currie, whose first design was rejected because of its 'great expense', and he had to simplify the windows in his second, cheaper, design. Its construction was one of the first acts of a new town council elected in 1871, after the town had been run by managers for twenty years. It has a sailing ship as its weathervane.

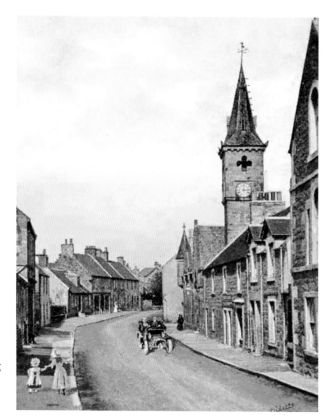

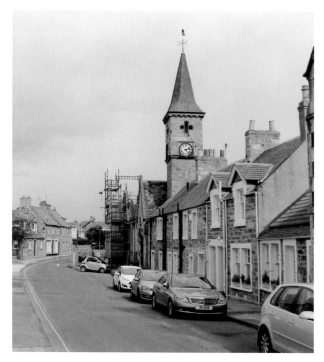

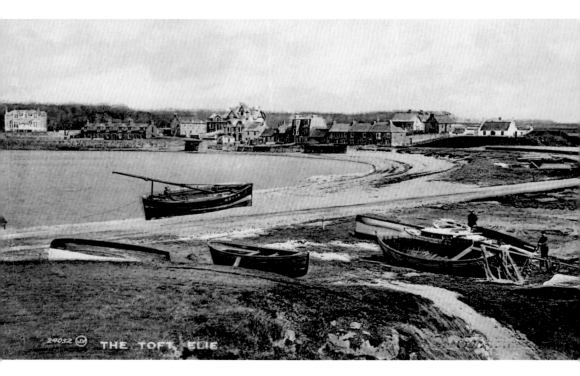

Elie, the Toft

Elie takes its name from the island on which the granary stands – from the Gaelic *ailie*, meaning 'out of the sea', or from *ey* the Norse for 'island'. The harbour was developed in 1582 and the town became a Burgh of Barony in 1589. In the 1850s the harbour was improved and the present causeway and road were built.

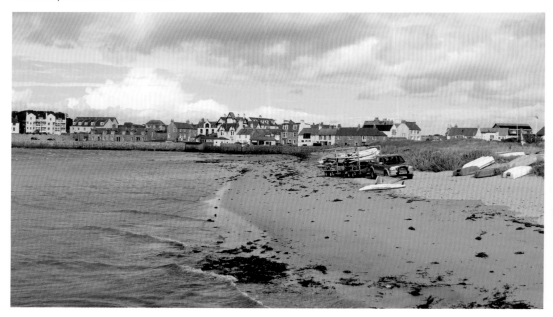

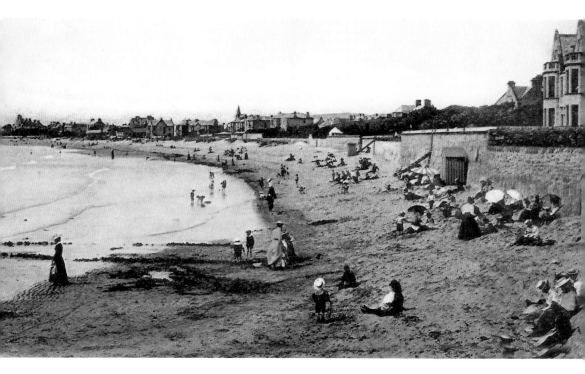

Elie Beach

Elie, with its extensive beaches, has long been a popular holiday resort and bathing place – as early as 1791–99, the *Statistical Account of Scotland* noted that 'the shore at Elie is remarkably well adapted for sea bathing; and is, of late, much resorted to for that purpose'. Throughout the nineteenth century, paddle steamers plying the Forth brought day trippers from the likes of Leith and North Berwick. This substantially increased when the Galloway Saloon Steam Packet Company built a timber jetty in 1889/90 to allow the paddle steamers to berth at Elie in all tidal conditions. The opening of Elie railway station in 1863 provided another boost to Elie's convenience for visitors.

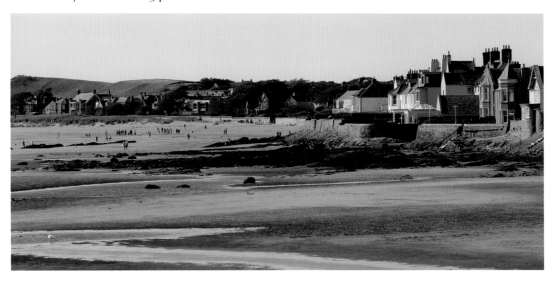

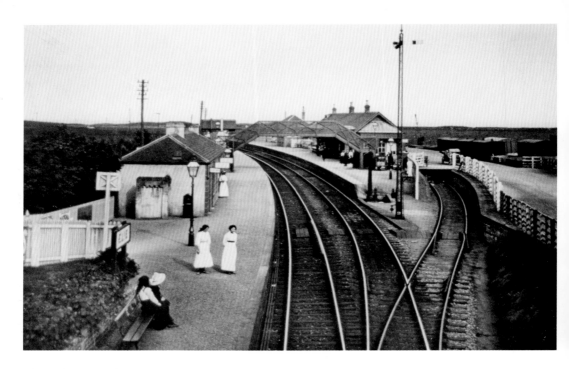

Elie Railway Station

Elie railway station opened on 1 September 1863 as an extension from Kilconquhar. Elie was just one of the towns in the East Neuk that was once served by the Fife Coast Railway. The line reached Kilconquhar in 1857, was extended to Anstruther in 1863 by the Leven & East of Fife Railway, and, after a takeover by the North British Railway, reached St Andrews in 1893. In 1910, it took 2 hours to travel the full route from Thornton to St Andrews, special trains were laid on at peak holiday times and huge quantities of fish were transported. Despite a campaign to keep it open, the whole of the East Neuk line (except the St Andrews branch from Leuchars) was closed in 1965. The site of Elie station is now a small housing estate.

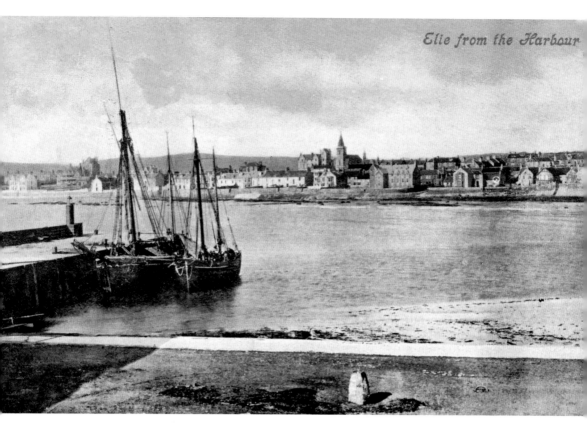

Elie Harbour
Elie, with its deep water, was noted as a haven for boats in the late fifteenth century. The harbour pier was rebuilt and lengthened in the 1850s and it began to take trade away from Earlsferry.

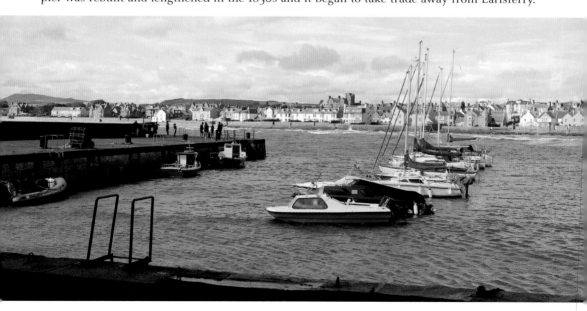

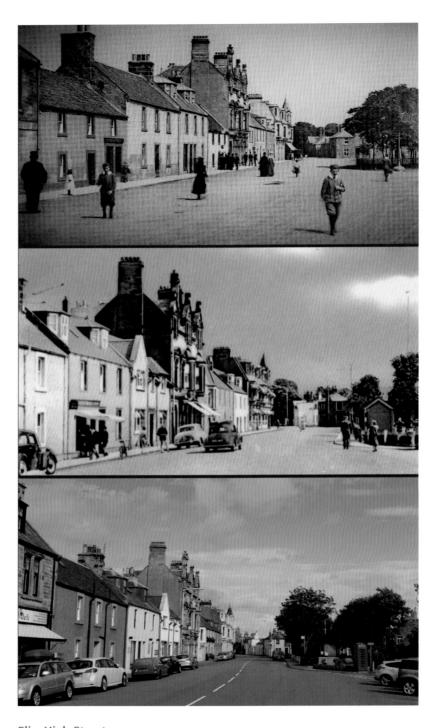

Elie, High Street
The changing scene on Elie High Street is reflected in these three images. The turreted building in the background was built as the Queen's Hotel in the 1890s.

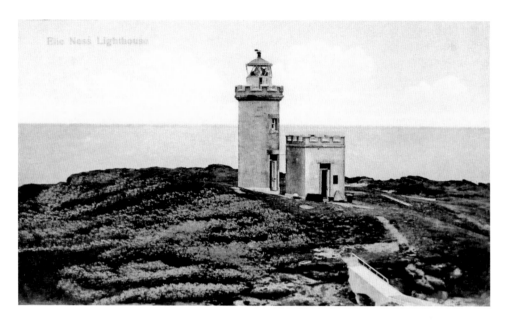

Elie Ness Lighthouse

The 36-foot-high Elie Ness lighthouse first officially shone a light to assist navigation on the Forth on 1 October 1908. The engineer was David Alan Stevenson, grandson of the famed lighthouse engineer Robert Stevenson and cousin of Robert Louis Stevenson. The light flashes every 6 seconds and is visible for 18 nautical miles. In the very early part of the twentieth century pressure was building on the Commissioners of Northern Lighthouses for the erection of a lighthouse on Elie Ness. Master mariners of all nationalities argued that in bad weather, when off Elie Ness, they couldn't see the light on Isle of May or on Inchkeith. David Stevenson reported in 1909 that 'the light is a powerful one and is giving satisfaction to sailors'.

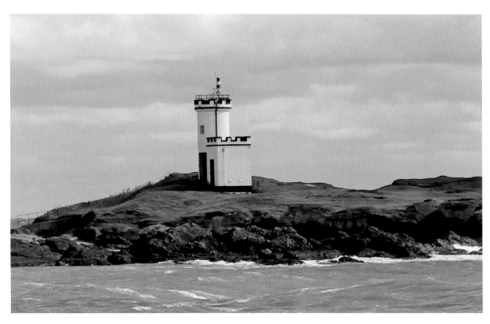

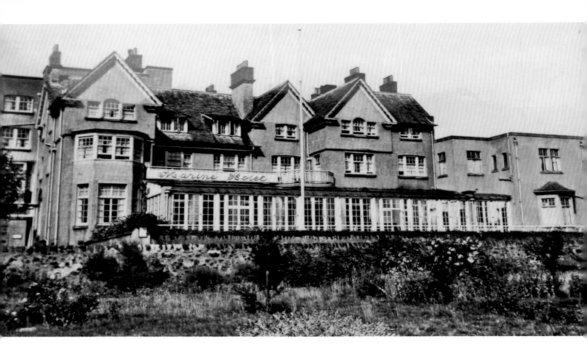

Elie, Marine Hotel

The first Marine Hotel, which opened in Elie in 1888, was gutted by a fire in 1904. It was rebuilt on a grander scale in 1907 and was extended a number of times over the years. The hotel closed in the 1970s, was used as a nightclub for a time and was demolished in 1984, following a fire the previous year. The site was redeveloped as housing in 1990.

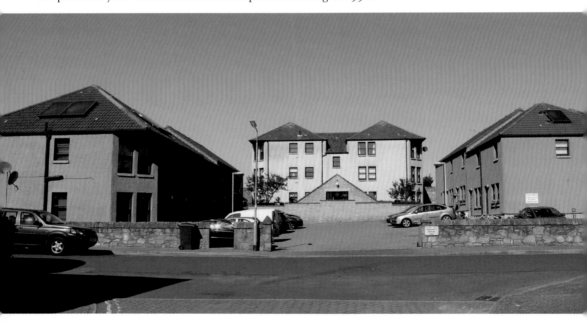

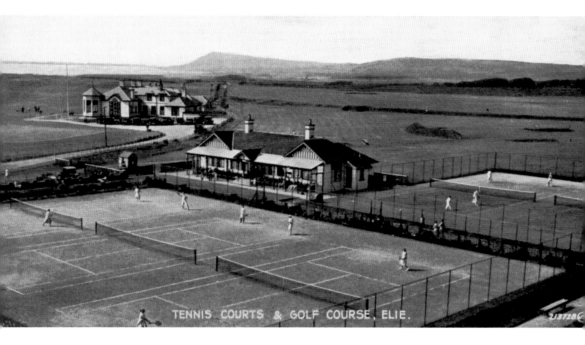

TENNIS COURTS & GOLF COURSE, ELIE.

Earlsferry and Elie Golf Course

Golf has been played at Elie and Earlsferry since at least the sixteenth century, a royal charter of 1589 granting the right for the game to be played on 'the golfing tract', and the course is among the oldest golf links in the world. The Elie and Earlsferry Golf Club was formed in 1832 and the current club, the Golf House Club, was established in May 1875 with the building of the clubhouse. The current course was designed by Old Tom Morris and James Braid in 1895. James Braid (1870–1950), the five-time Open Championship winner between 1901 and 1910 and renowned golf course architect, was born in Earlsferry. Braid's achievements are commemorated by a plaque at Earlsferry Town Hall. The tennis courts were laid out in 1905 and the adjoining pavilion built in the 1920s.

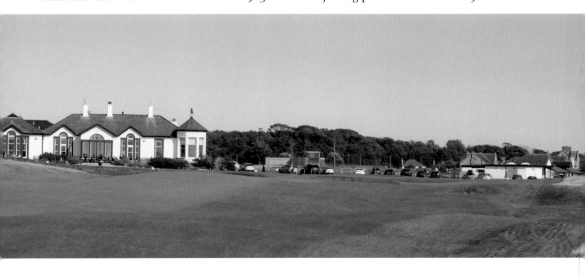

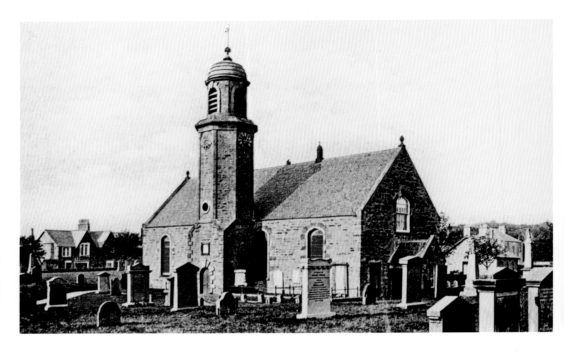

Elie Parish Church

Elie parish church was endowed by William Scott of Ardross and opened for worship on 4 August 1639. The tall hexagonal tower was commissioned by Sir John Anstruther in 1726 and the building was significantly refashioned in 1831. The clock on the tower only has three faces, as there were no houses on the north side when it was installed in 1900.The war memorial on the outer corner of the churchyard wall lists the names of the fallen from the village and, unusually, provides the pre-war trades of each man.

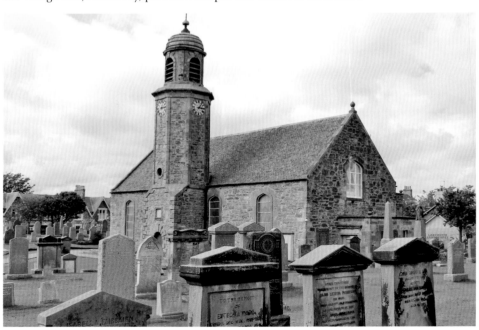

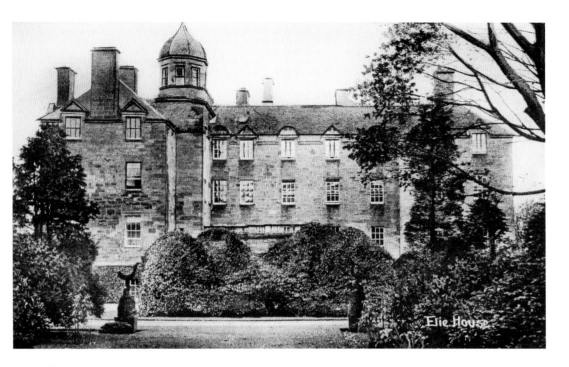

Elie House

The grand Elie House was built in 1697 by Sir William Anstruther, incorporating the remains of an earlier mansion house built by Sir William Scott in the late sixteenth century, and has been the subject of substantial alteration over the centuries. The house was used as a retreat by the Marie Reparatrice order of nuns from the 1950s until 2000, when it was bought for conversion to flats.

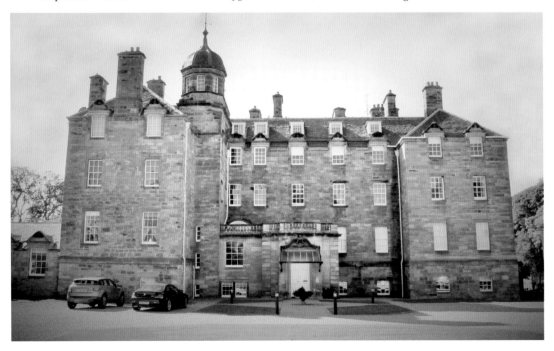

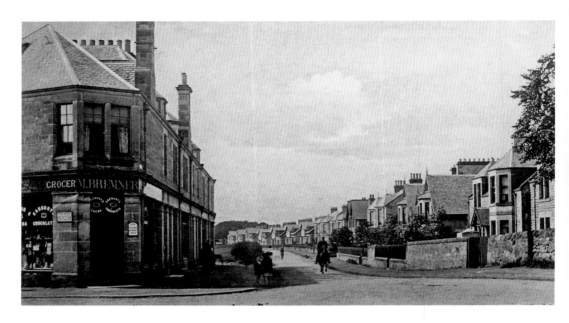

Lundin Links, Leven Road

Lundin Links was originally three villages – Lundin Mill, Newton of Lundin Mill and Emsdorf. The town takes its name from the Lundin family, who were granted land here in the twelfth century, and as the names suggest milling was the principal activity from the seventeenth century. The town developed as a nineteenth-century suburban extension of Lower Largo for the accommodation of holiday makers. The corner premises of M. Bremner in the older image seems to have served a number of functions – grocer, agent for dry cleaning by Pullars of Perth, post office – and must have been central to village life at the time.

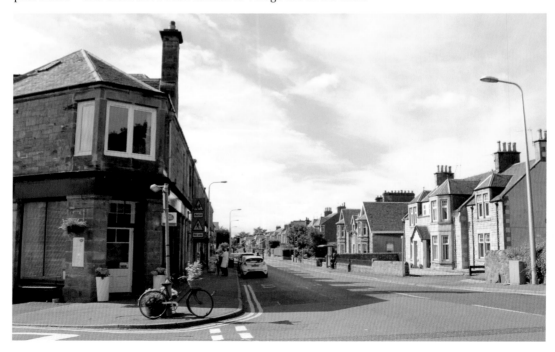

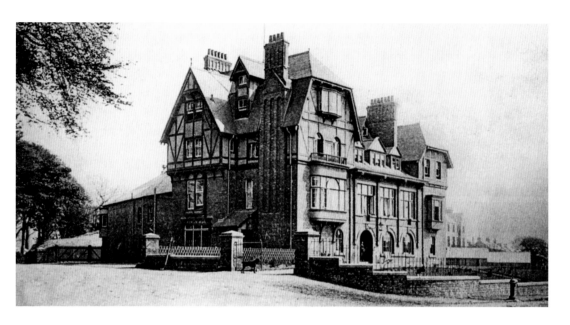

Lundin Links Hotel

The Lundin Links Hotel is a large and distinctive Tudor Revival building prominently located on a corner site in the village and is a key landmark which heralds arrival in the East Neuk from the south on the scenic coast road. The building dates from 1900 and was designed by the architect Peter Lyle Barclay Henderson. Henderson was captain of the Lundin Links Golf Club when the hotel was built and was also the architect of the golf clubhouse. The site has been the location of an inn in some form or another since the seventeenth century. The hotel ceased trading in early 2014 and there were previous proposals for its demolition. At the time of writing, the plan is for its conversion to flats.

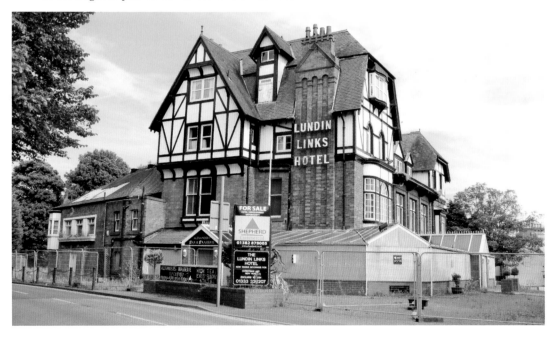

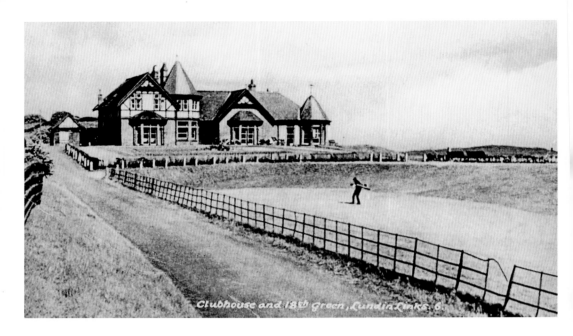
Clubhouse and 18th green, Lundin Links. 6.

Lundin Links Golf Course

It is no surprise that the East Neuk with its proximity to St Andrews, the Home of Golf, boasts some excellent golf courses. The Lundin Golf Club at Lundin Links is among the best and was founded in 1868. In 1908, a new course was laid out by the renowned golf course designer James Braid on part of the original course and on the nine-hole Lundin Ladies' Golf Club – the ladies were displaced to a new course designed by James Braid in the Standing Stanes Park. The first ball on the new course was struck on 29 November 1909. The Lundin Ladies' Club was established in 1891 and is one of the oldest women's golf courses in the world. There is a small group of ancient standing stones on the second fairway of the ladies' course.

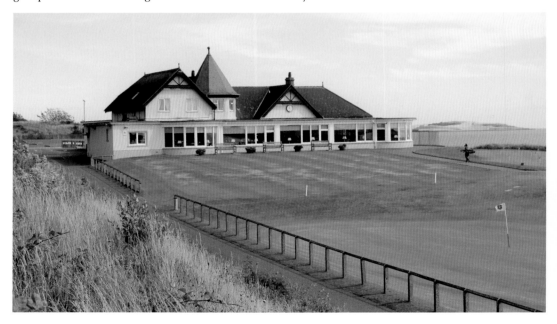

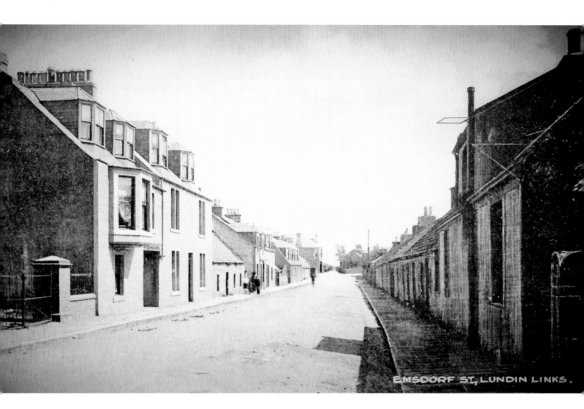

Lundin Links, Emsdorf Street

Emsdorf, or Over Drummochy, was once a distinct village, and the curious name may be German in origin – the German word dorf translates as village and it is a common suffix in place names in Germany, Austria and Switzerland.

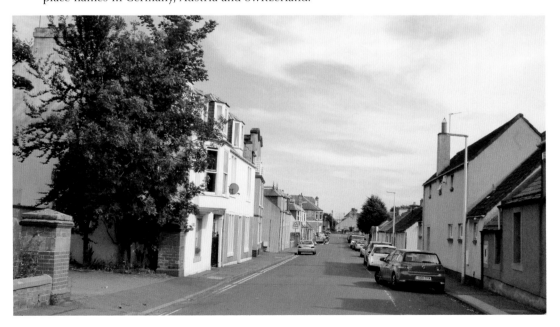

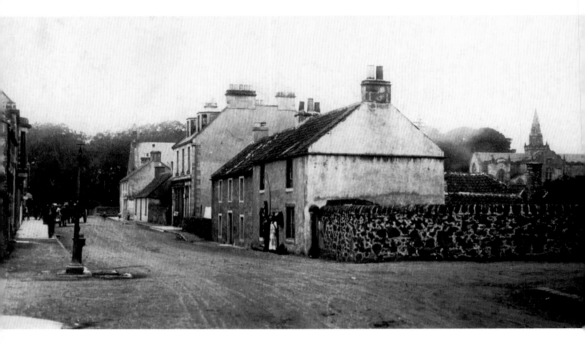

Upper Largo, Main Street
Upper or Kirkton of Largo developed around the church and later along the coast road. Its main industry was the production of linen and there were once numerous bleaching greens in the village.

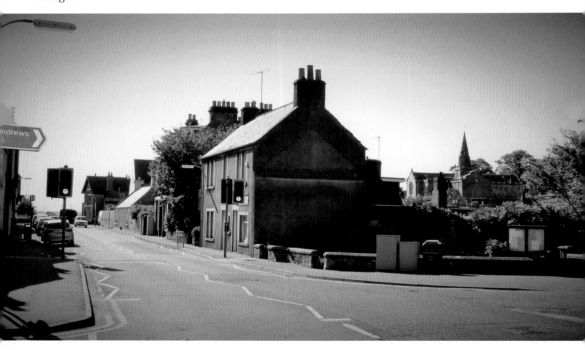

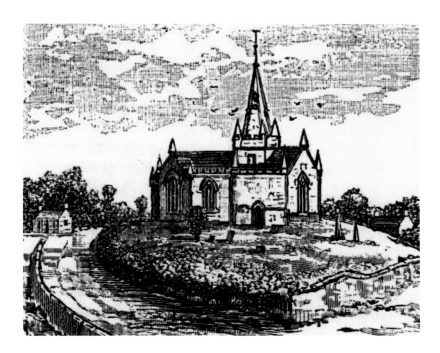

Upper Largo Church

Largo church occupies a dominant location on raised ground surrounded by its graveyard. There has been a place of worship on this site since at least the eleventh century. The present church was constructed in 1817 by local architect Alexander Leslie, incorporating parts of an earlier seventeenth-century building. The graveyard includes the Largo Stone, a Pictish cross slab, and the graves of the Selkirk family – Alexander Selkirk, the model for Daniel Defoe's *Robinson Crusoe*, was a member of the parish.

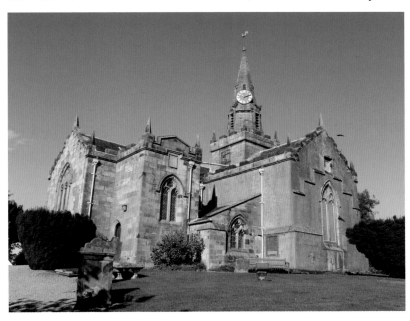

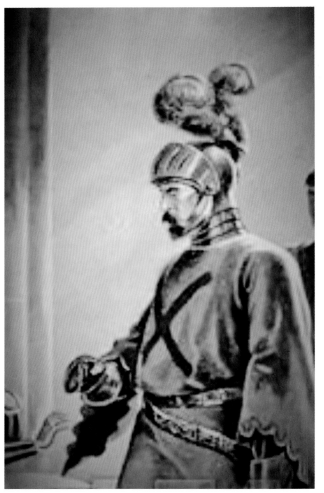

Sir Andrew Wood of Largo
Wood's Hospital, Upper Largo's most elaborate building, was built as an almshouse in 1830 and was converted to housing in the 1970s. The building takes its name from Sir Andrew Wood, Upper Largo's most renowned son, who was known as 'Scotland's Nelson'. Wood began his career as a merchant and privateer working out of Leith with two ships. He was the hero of a sea battle in the Firth of Forth against the English, in which he was outnumbered in both ships and guns, and was the first captain of James IV's huge ship the *Great Michael*, the flagship of the Royal Scots Navy, launched at Newhaven in 1511 and the largest ship in Europe at the time.

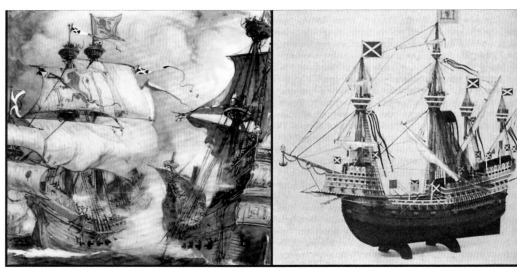

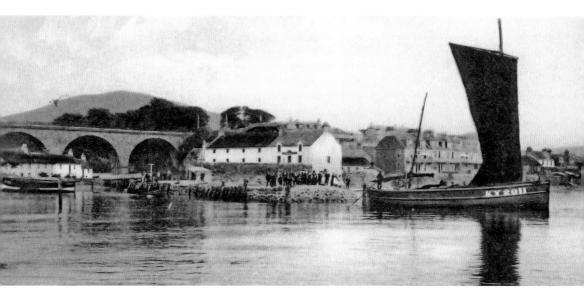

Lower Largo

Lower Largo, or Seatown of Largo, developed as a fishing village at the mouth of the Keil Burn. It was made a Burgh of Barony in 1513, which gave the town the right to erect a mercat cross and hold its own weekly market. In the first half of the nineteenth century Largo was a centre for the production of linen. This declined with the introduction of power looms in the larger towns. In 1867, many of the handloom weavers found work in the newly opened Cardy Net Works which manufactured fishing nets and closed in 1886. There was also a thriving mill for the production of linseed oil.

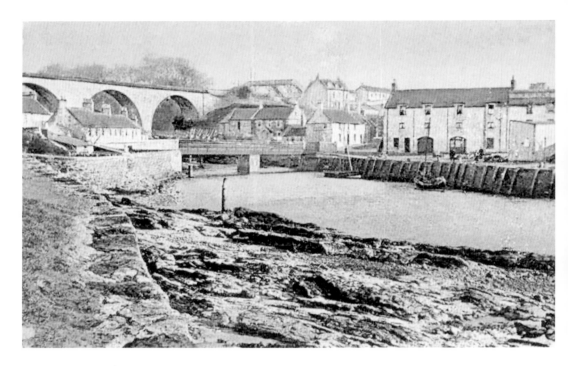

Lower Largo Harbour

There has been a haven for boats at Lower Largo, where the Keil Burn flows into the Forth, since at least the sixteenth century. The pier was built in around 1770 and was extended in the early nineteenth century, although it never had an enclosed harbour like most other East Neuk fishing villages. The harbour once served a herring fleet of nearly forty fishing boats and was important for the export of local agricultural produce and coal. The railway station can be seen to the right of the viaduct in the older image.

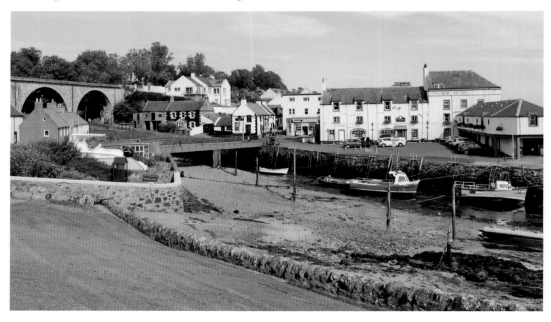

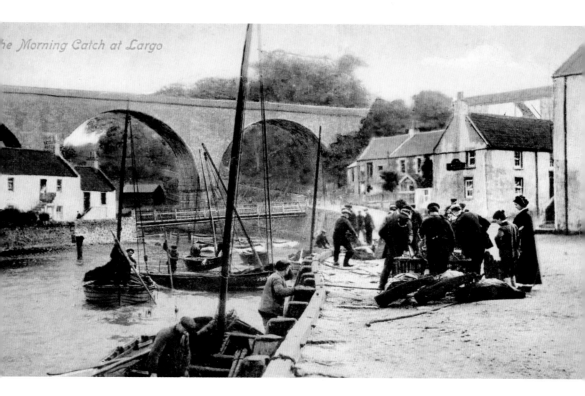

Lower Largo, the Morning Catch

In 1861, there were fifteen boat owners and skippers resident in Lower Largo. By 1930, the industry had all but disappeared.

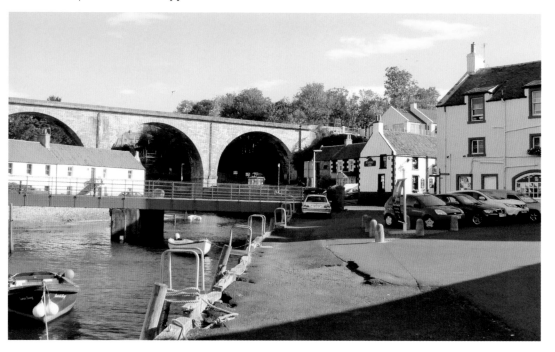

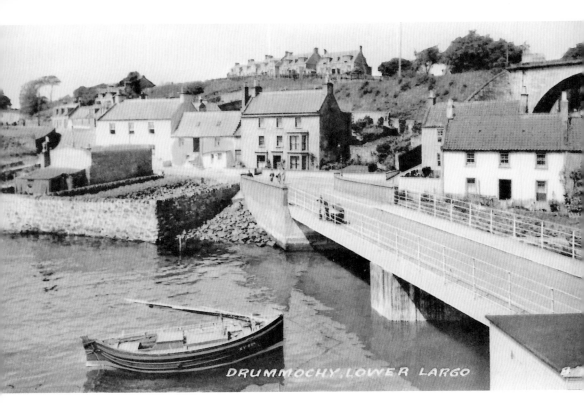

Lower Largo, Drummochie
View looking towards Drummochie, which was once an independent village. The steel bridge over the Keil Burn dates from 1914 and replaced an earlier wooden footbridge.

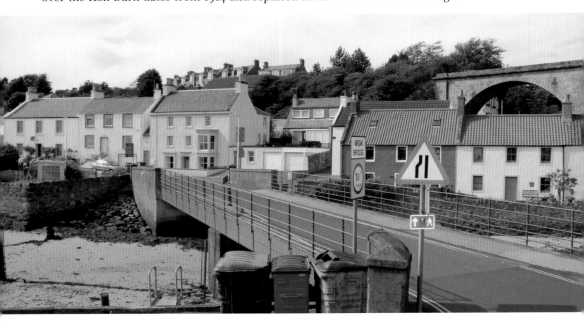

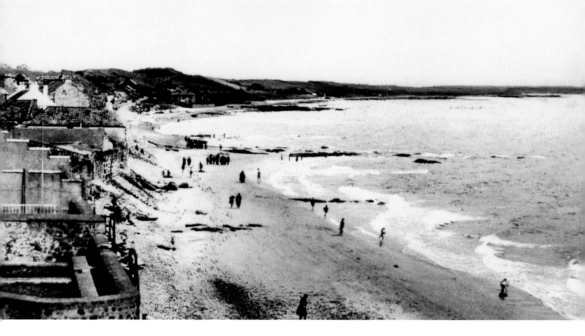

Lower Largo, Beach from Crusoe Hotel

The picturesque setting of Lower Largo around the long sandy beach of the wide crescent of Largo Bay has long been an attraction for visitors. A seasonal twice-daily steamboat ferry service between Newhaven and Lower Largo brought tourists from Edinburgh in the mid-nineteenth century, with coaches taking visitors further afield to Anstruther, Elie, and St Andrews. The arrival of the railway in 1856 brought many more tourists to Lower Largo's sandy beach. In the fifties, before the days of international travel, the East Neuk villages were hugely popular as summer holiday resorts. The houses on the coast side of the narrow Main Street back directly onto the sea and are protected from high tide by a substantial sea wall.

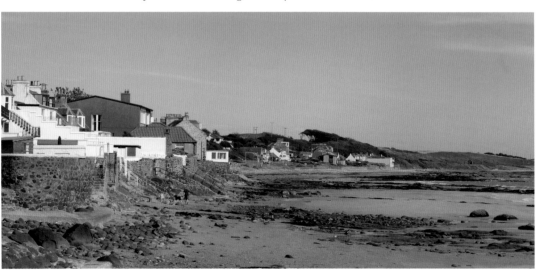

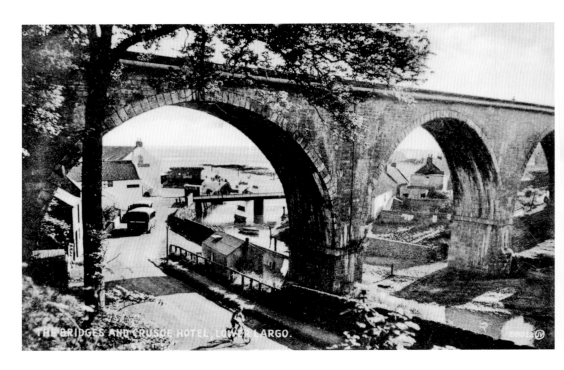

Lower Largo, Railway Viaduct

The disused old four-span railway viaduct is a major landmark in the harbour area at Lower Largo. It dates from 1856/57 and carried a single track of the East of Fife Railway Company line. Lower Largo station opened on 11 August 1857 and closed on 6 September 1965. The station played a major part in the growth and prosperity of the town.

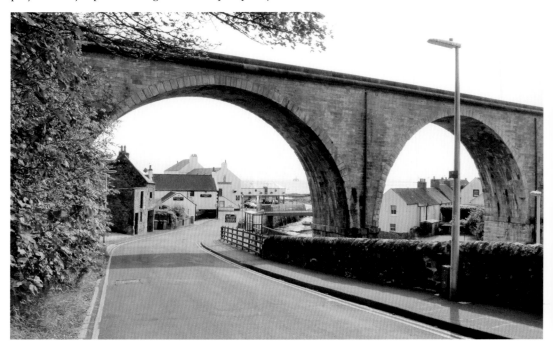

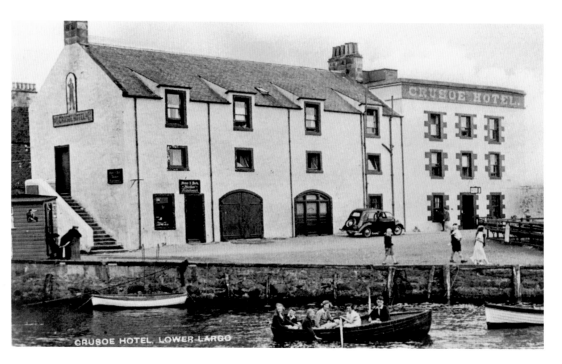

Lower Largo, Crusoe Hotel
The Crusoe Hotel has long been a feature of Lower Largo. It has gone through many changes over the years but still remains a picturesque addition to the harbour area. The building was originally constructed as a granary in 1824, which was partially converted to an inn in 1828, when it was known as the Harbour Inn. The name Crusoe Hotel, which dates from later in the nineteenth century, was no doubt adopted to capitalise on Alexander Selkirk's connection with Lower Largo.

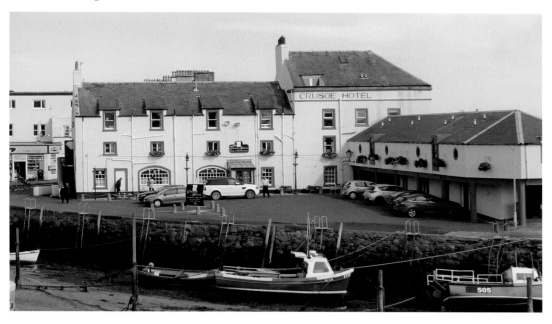

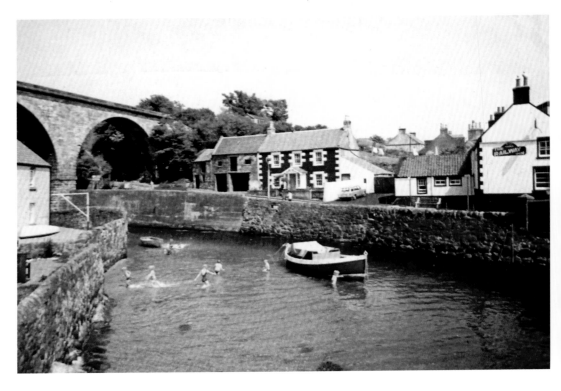

Lower Largo, Keil Burn
View of Lower Largo from the Drummochie side of the Keil Burn – the Railway Inn and
Bridgend House are prominent in the foreground. The site of the large house in the background
of the more recent image was occupied by the Belmont Temperance Hotel, which was built
around 1890 and gutted by a fire in January 1926.

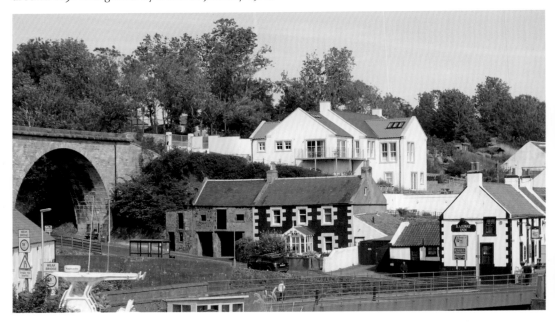

Lower Largo, Alexander Selkirk

In 1676, Alexander Selkirk was born in the house in Lower Largo shown in the older image. His father was John Selcraig, a prosperous shoemaker. In 1704, Selkirk was sailing master of the privateering ship *Cinque Ports*. Arguments broke out and Selkirk decided that he would rather be left on Más a Tierra, 670 km (420 miles) off the coast of Chile. Selkirk was marooned on the island for four years and four months. He was remarkably self-reliant – building huts; catching seals, shell-fish and goats for food; fashioning clothes from goat skins, and training feral cats to protect him from voracious rats while he was sleeping. This story was widely reported and was thought to have inspired Daniel Defoe's 1719 novel *Robinson Crusoe*.

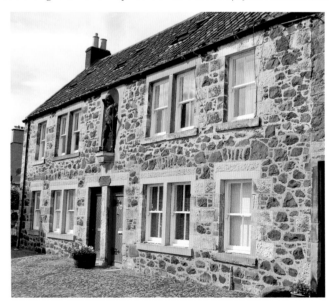

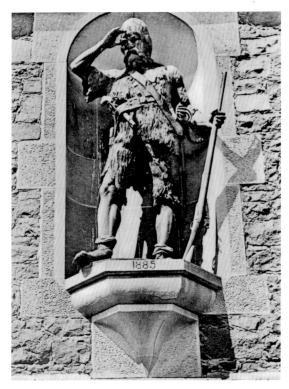

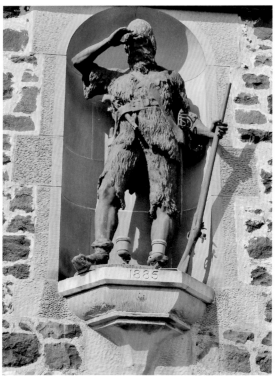

Lower Largo, Alexander Selkirk Statue
On 31 January 1709, Alexander Selkirk was eventually rescued by a passing ship and returned to Lower Largo in the spring of 1712. While in the village, he lived in a cave in the garden of the family home. In 1717 he eloped to London with a local woman. Selkirk continued a seafaring life and was buried at sea off the coast of West Africa in 1721. Selkirk's house in Lower Largo was demolished in 1865. On 11 December 1885, a bronze statue of Selkirk in the guise of Robinson Crusoe was unveiled in a niche of the new building on the site of his birth. In 1966, the Chilean government renamed the island on which Selkirk was marooned Robinson Crusoe Island, with another island renamed Alejandro Selkirk Island.